...TOUCHED...
BLUE

Ursula Rani Sarma

...TOUCHED...
BLUE

OBERON BOOKS
LONDON

WWW.OBERONBOOKS.COM

First published in 2002 by Oberon Books Ltd
521 Caledonian Road, London N7 9RH
Tel: +44 (0) 20 7607 3637 / Fax: +44 (0) 20 7607 3629
e-mail: info@oberonbooks.com
www.oberonbooks.com

Cover painting by Suzanne Coley
www.suzannecoley.com

Visit www.oberonbooks.com to read more about all our books and to
buy them. You will also find features, author interviews and news of
any author events, and you can sign up for e-newsletters so that you're
always first to hear about our new releases.

Contents

Preface, 7

Acknowledgements, 9

...touched..., 11

BLUE, 41

Preface

The process of writing and directing ...*touched*... in many ways brought about a major turning point in my life. I had just completed my degree and was unsure what direction my life was about to take, then in a matter of months, ...*touched*... cemented my future firmly in literature. ...*touched*... was born out of something very tragic and dark, the sexual abuse of a young girl. I wanted to write something about abuse, both psychological and physical, and how it is most often bestowed on the vulnerable and the innocent. Sexual and physical child abuse has emerged as a national tragedy for Irish society as the nation reels from allegations and evidence of related offences. I have always felt passionately that the innocence of childhood is a gift and the taking or loss of that innocence, a great tragedy. ...*touched*... was inspired by this loss of innocence and also by the importance of honesty and friendship, love and mutual dependence that can exist between two people. Finally, ...*touched*... is first and foremost a fictional representation of a real nightmare. Having been fortunate that I never experienced the kinds of abuse addressed by the play, I endeavoured to create a vivid and realistic depiction of the horror which Cora experienced.

Blue is set in a small seaside village in the West of Ireland, similar to the one where I spent my own childhood. Initially, it came from a respect for the ocean that was drilled into me as a child. This respect, mixed also with fear and wonder, produced the character of Des. As I began to write *Blue*, I became immersed in the relationship between Des and his two best friends. It is set at that point in time when childhood ends and something else must begin and explores how the three deal with this turning point in such different ways. The love and dependence between Des, Joe and Danny suddenly became the most important factor. Also, I wanted to illustrate how outside forces, such as the seeming excitement of urban night life, can creep in and affect the apparent innocence of a rural seaside village. I have a strong connection with the characters of *Blue*. They have always felt like friends and neighbours to me.

Acknowledgements

...touched...

The first production of *...touched...* would not have been possible without the tireless enthusiasm, creativity and support of Kate Neville. Thanks to the staff and crew of Hillstreet Venue, particularly Judith Ironside and Tomek Borkowy. Thanks to Ali Robertson and Maeve in the Granary Theatre in Cork City. Also thanks to John Cumisky, Keith Neary and Monica Spenser. Last but not least, a huge thank you and much love to my wonderfully supportive family, to Frances, Susmita and Kiran, I couldn't ask for more inspiration and encouragement from all of you.

Blue

Thanks to my wonderful cast and crew, to Gerry Barnes and all the staff at the Cork Opera House. To Cormac O'Connor for the wonderful sound and Cliff D'Olliver for a great set. To Paul MacCarthy and Joe Stocktale, Mick Hurly, Keith Neary, Monica Spenser and Kate Neville. To John Tiffany, John Fairleigh and Annemarie Shalloo for their continuing support and encouragement. Many thanks to Mel Kenyon and Casarotto Ramsay & Associates Ltd. To my family, extended family and close friends. Finally, very special thanks and love to Kevin O'Leary, for everything.

Acknowledgements

…TOUCHED…

this play is dedicated to

Frances, Susmita, Kiran and our beloved Monoviram

&

Kate Neville

I will never forget your kindness, your support and your friendship

Characters

CORA
a girl in her late teens, Mikey's sister

MIKEY
a boy in his mid teens, stronger physically than mentally,
Cora's brother

MACCA
a street wise city boy, rough, violent

DR CLOUGHASY
a sleazy man in his fifties

In the original production, the actor who played Macca
also played Dr Cloughasy.
The action takes place in a minimal setting, where only two
or three chairs are used. The lighting should be soft
predominantly, except in tense moments where direct harsh
spots can be used. It is important to note that a distinct
atmospheric change should be observed between the times
when the characters are speaking directly to the audience,
and those when they are talking to each other.

...*touched*... was first performed at the Hillstreet Venue, Edinburgh as part of the Fringe Festival 1999, and also in Ireland later that year, by the Djinn and Granary Theatre Companies of Cork, with the following cast:

CORA, Paula O'Donoghue
MIKEY, Mark O'Brien
MACCA / DR CLOUGHASY, Raymond Scannell

Director, Ursula Rani Sarma
Producer / Stage Manager, Kate Neville
Designer, Keith Neary

Lights up on three characters on stage, MACCA downstage, MIKEY and CORA upstage. Music begins and drops as a strong light snaps up on MACCA, who explodes into action. He is panting, nervous, agitated and moves rat-like, scurries rather than walks. Shaking with excitement, he walks further down stage towards the audience. Grinning, laughing.

MACCA: Christ...fucking hell man...what a rush... (*Laughs some more.*) We shot down through Grafton Street with a shower of pigs on our tails and more waiting at the top, they are still down there now, trying to sort out their arse from their elbow...
(*Pause.*)
We showed them...fucking pigs, too fat to move through the sluggy city anyway, what do they expect? Little fishy bastards in sardine cars. Your man there behind me... the tall guy, violent enough like, he got one big guy, a right one, straight into his fatty face. Up with it (*Illustrates punching someone beneath him.*) and down down down... (*Realises he was getting a bit carried away and pulls himself together.*)
I was on my way back up to the bookies, a fiver each way on Trickie Dickie I thought to myself, then a nice pint and a chaser down in Moran's with PJ and the boys. This is what I was thinking when I met this guy flying around the corner, with forty fucking pigs on his back. He was with this girl and she was panting and sweating and straight off, I mean out of nowhere, he grabs my arm and asks me the fastest way to get onto Golton Street, all in a flurry like so 'Hold on hold on,' I said, 'You don't get nothing for nothing,' I said and straight out of his pocket he takes a right big wad of notes, twenties... I mean at least five hundred quid there and pushes them into my face, while down the street behind me the police were surging along like play dough and for a split second I did stop and have a bit of a think, you know, about the consequences. 'Macca,' I said to myself, 'a dodgy looking character with a bit of a skirt'...and I knew they were only looking for a reason to throw me back into Barrymount anyway. Barrymount... and the cells, the urine, the big slow-witted guys who lurk

in the corners and wait for you to pass by all alone, a grey
ceiling for your sky and the chains for your conversation,
blue shirted Northsiders with a badge and a club and a
complex that leaves you face down bleeding into concrete
twice a day.

(*Changes back to high mode.*)

But fuck me lads, five hundred quid for directions and
a quick sprint, and fucking hell what a rush... I brought
them down Spindler's Street and under George's Bridge,
we waited until they had passed overhead and made a run
for it. That's when we met with the two big guys, too fatty
to keep up with the rest who had rounded the corner in
front. He came at me all thumbs and fumbles, lifted me
up by my shirt like a child, was just going for my forehead
with his big sausage fist (*Turns.*) when the other guy goes
for the girl and she fell trying to run and picking her up
he was, (*Building up.*) when your manno here comes like a
rush all strong with the force of his fist and down, down,
down...left him bloodying the pavement and I (*Shrugs.*) ...
sure I ran like crazy my heart beating hooves against my
chest, my lungs in my fucking mouth, I tell you what a
fucking rush... (*Quieter.*) what a rush, what –

(*Freeze and cut to MIKEY, wide eyed, innocent seeming.*)

MIKEY: – the fuck was he doing? Going for a girl like that,
I mean what did he expect? But straight off now, I'll tell
you, it was no accident, I'll say it now and I'll say it to the
fuckin' Gardai when they catch up with us. And this guy
(*Gestures to MACCA.*) ...what we're still doing with him I
don't know. Look at him, city slimy dodgy fucker, thought
he was going to stand there and fucking applaud when I
hit your manno back there. And in fairness now, I didn't
mean to hit so hard either, but he was going for Cora and
he had pushed her on to the ground and...I mean, that's
just asking for it. It was self-defence anyway, if Cora was
stronger she would have hit just as hard, but she's small so
it's Mikey's job to look out for her.

(*Pause.*)

Last thing I saw before my fist hit his flesh, was this thin
wedding ring on his finger, a real cheap thin band almost

lost in folds of fatty flesh and (*Confused.*) I hit him all the harder that time…and it's only my second or third time ever…the first was at school when this guy Tony Curtain was saying things about my Mam and I…

(*Pause. Distressed.*)

You don't remember the last few seconds before you actually do it…actually start with the fists…it just comes on you like a shock of heat and then it's over…and you've got their blood on your hands and shirt and…and I don't know if I really felt sorry as such…I mean the little shit was asking for it and that gave me the right.

I felt a bit sick though, with Tony crying into the earth on the soccer pitch with all the others chanting scrap scrap scrap…and afterwards sitting in Mr Corley's office, staring out the window for Auntie Mary's car to arrive,

I felt something like an itch in… (*Points beneath his ribs.*) … in here. And back in the pub that evening…above in the store-room with Cora standing at the doorway watching and crying, I was…definitely sorry then…but that was because it's –

(*Freeze and cut to CORA.*)

CORA: – Dublin City, thirty-first of December 1999, and I am fucking freezing.

(*Stops and paces.*)

I had a jacket before, and a change of clothes in case we got caught in the rain or whatever…and some food…and a doll I got from my uncle when I was five and a picture of my mother standing in a yellow dress…and a bottle of Powers that we took from the bar the night we left. I had to dump it all when we had to sprint down from the shop, it was too heavy and we needed the bag to put cash into anyway…so it's all at the shop now. I reckon we should leave it until twelve o'clock and they are ringing in the new year because they'll all be busy with the crowds and the parade to worry about us…and with the peace talks breaking up again…and all the protests going on in the city…we should make it then. Truth is your manno back there, the Garda, he didn't push me as such, more like I

fell, tripped or whatever, but it was easier to say he did…
because I could see Mikey hesitating and between yourself
and myself, (*Pause.*) we are up to our ears in this, way
deeper than I ever…well anyway…he just doesn't think,
Mikey, he stops and lets it all twist and fumble around
inside his skull and by the time he's come up with an idea
of how to respond, the moment…fuck it, the hour, has
passed…and we wouldn't be here now… we'd be sitting in
some grey cell waiting for their playschool brains to piece
the pieces together and I didn't get us through all that back
water to be dragged down by some fat bastard of a Garda
who can't even keep chase with the rest of them, and
he went down because he deserved it, hit the pavement
because he should have…and there's only tonight between
us and away.

(*Cut to the two boys who step forward and pant in unison.*)

MACCA: Wow man…

MIKEY: Fucking hell…

MACCA: Down, down, down, hah?

MIKEY: Uh…suppose…

MACCA: Fucking magic.

MIKEY: Got him straight into the face…

MACCA/MIKEY: (*Both demonstrate with a punch into the air.*)
Straight in and (*Drop to their knees and strike in unison.*)
down, down, down…

CORA: Mikey, stop it.

MIKEY: (*Chastised and meek suddenly.*) Sorry Cora.

MACCA: Mikey is it?

MIKEY: Yeah.

MACCA: Macca, (*Offers his hand, which MIKEY rejects.*) pleased
to meet you, so…what's the story with the old cashish
then? …I don't take no cheques or nothing …major credit
cards only…

(*MIKEY pays him.*)

Nice one…notes…pleasure doing business with you.

(*No answer.*)

Right. Yeah. So. That's the way then. What a rush man.
You know, down, down, down.

(*Two of them are getting carried away, mock fighting.*)

CORA: Mikey, I said stop it for Christ's sake…

MIKEY: Sorry Cora.

CORA: Yeah, well. We'll be seeing you then.

MACCA: (*Very disappointed.*) D'ya not want me to show you…I could bring you down nearer to the station, I know all the back streets…I know people who know people, d'ya know like?

MIKEY: Thanks?

CORA: But no thanks –

MACCA: – I could arrange for a –

CORA: – Really, we're fine thanks…

MACCA: Right then…well…thanks…pleasure doing business with you…er…I…right right, I'll be off then… (*Goes to leave.*) …only trying to help.

(*MACCA can either exit or wait motionless as the edge of the stage.*)

MIKEY: What if someone knows?

CORA: No one knows.

MIKEY: What if someone saw?

CORA: No one saw.

MIKEY: What do we do now?

CORA: We wait. (*Checks her watch.*)

(*Freeze. MIKEY and CORA move downstage and start. They tell the story like kids, each cutting the other off and trying to be the one at the centre of attention.*)

We live down in the crotch of the country.

MIKEY: With my Uncle Dan and my Auntie Mary, named after the good woman above.

CORA: But who must be working for the cunt below. They own a small pub and we went there in December 1980 after I was born.

MIKEY: And after Mam died, because Uncle Laurance was away on business and he couldn't make it to the hospital in time.

CORA: We were only supposed to stay there for a week or so.

MIKEY: Until he came back from America, but then he arrived one day.

CORA: All slick in a blue suit and a wide smile, and explained that Dublin was no place for children.

MIKEY: And how he was away on business a lot and...

CORA: Well anyway...for as long as I can remember all I've wanted.

MIKEY: All we've wanted.

CORA: Is to leave, we had a plan.

MIKEY: Me and Cora, about getting away, coming up to the city.

CORA: Dublin.

MIKEY: Dublin...up to Uncle Laurance and we've seen the shiny postcards stuck behind the mantle in the back room.

CORA: With the Liffey all bright and shining, and all those pretty people in pretty clothes.

MIKEY: With pretty smiles and laugh lines.
(*Switches back in time, both quite young.*)

CORA: When we leave I want to take the yellow suitcase Mam had, all right Mikey?

MIKEY: O'course.

CORA: And I want to bring the hat that she's wearing in that photo of her in the drawer, all right Mikey?

MIKEY: O'course and Cora I'll –
(*Enter DR CLOUGHASY, man in his fifties, upper class accent but with a definite sleaze about his person. CORA reacts to his voice and shrinks away.*)

CLOUGHASY: Hello there now and how are we all at the ould place today, isn't it a glorious day lads, hah? A beautiful [beaudiful] day by all accounts. Ah, there you are Cora, how are you, young lady, are you behaving yourself?

MIKEY: (*To the audience.*) Dr Cloughasy. He calls in twice a week for his lunch while his wife is at her ICA meetings.

CORA: He's sweaty and red and he smells of onions and antiseptic and he has this way of repeating his words over and over, like they're some taste he doesn't want to get rid of out of his mouth.

MIKEY: Mrs Smith who works in the kitchen calls him a poofter but Auntie Mary makes us talk nice to him, but I'd like to ram that briefcase right up his fat sweaty a –
(*Interrupted by CORA, painfully shy.*)

CORA: Hello Dr Cloughasy, yes Doctor.

CLOUGHASY: Aren't you absolutely marvellous, marvellous

altogether…mmmm…and looking smashing today I must say, smashing, going to break some hearts before you're old and grey as they say, isn't that what they say, Mikey? Hmmmmm…sure that's what they say… I'll have the same as usual, Mary, with lashings and lashings of your delicious gravy, enough to swim away on (*Laughs.*) but back to you, my lovies, I hope ye are not wasting your time on these lovely summer days…should be out and about, isn't that right Mary? Out and about but I do say you're looking very pretty today, Cora, is that a new dress, isn't it lovely and yellow, same colour as the primroses, isn't it Cora? (*Changes…more sleazy. MIKEY has back to them but turns around when he hears the change in his tone, but CLOUGHASY changes back just as quickly.*) You're a lovely little thing all right (*MIKEY turns, CLOUGHASY changes back.*) just like your mother, isn't that right Mikey, Lord have mercy on her soul, I remember when she was Cora's age and it…

CORA: (*To the audience.*) Nine years old today. Mikey made me a cake with nine candles on it. We were eating it upstairs in the storeroom and laughing and Mikey was teaching me how to play poker and how to cheat, when we heard him come through to the bar downstairs.

CLOUGHASY: Hello there now and how are we all at the ould place today, isn't it a glorious day lads, hah? A beautiful [beaudiful] day by all accounts.

CORA: And then my Auntie calling me down and I didn't want to go, I mean I really didn't want to go, and I wanted to hide or just to run or to scream or to do anything…but I didn't want to go down there to him, didn't want to go. Mikey said he probably wanted to give me a fiver for the day that was in it so…

CLOUGHASY: There you are now, and looking smashing again, you'll be turning heads one of these days now, isn't that right Mikey?
(*MIKEY ignores him.*)
Anyway, your Uncle Dan was below at the post office and he was telling me that it's some young girl's birthday, is that right Cora? …and I was thinking I might bring her

for a special treat for the day that was in it, if that young girl was to be a good little girl, maybe for some ice-cream down by the shore...hmmmmmmm?

CORA: (*To him.*) Thank you, Doctor, but I've just had cake, no room for ice cream, (*To audience.*) I said, but my Auntie says –

MIKEY: (*As Aunty Mary.*) No room for ice-cream, what child has no room for ice-cream, the kind Doctor is being very generous with his time, Cora, and all you can be is ungrateful.

CORA: No...it's just... (*Desperate.*) can Mikey come too?

MIKEY: (*As Aunty Mary.*) That boy isn't going anywhere, he has to mind the bar while I go into town, I can't do it all on my own you know.

CORA: (*Pulls MIKEY aside.*) I don't want to go, don't want to, don't want to...

MIKEY: What's the matter? It's only for some ice cream, you'll be back before you know it.

CORA: Don't want to go, don't want to, don't want to.
(*Change. Music. Sea sounds and blue wash. Standing beside each other DOCTOR and CORA. Eating ice cream.*)
Down by the dunes.
(*Pause.*)
We're watching the boats.
(*Pause.*)
The ice cream in raspberry ripple, cold and sweet. (*Pause.*) I push open the car door and walk away towards the sand... There's not another soul in sight. Out by the cliffs there is a small boat and I think it's Johnny Kelleher and I wave (*Waves enthusiastically for a moment only to register disappointment and drop her hand by her side.*) but he's too far away...and I'm too small anyway. The sun is melting and there is ice cream running down my fingers onto my dress and (*Freeze.*) I hear him close the door behind me. Footsteps on the gravel and the hand on my shoulder. I turn so slowly and – I'm finished now, Doctor, thanks Doctor, I'm ready to go now, Doctor. Can we go now, Doctor.

CLOUGHASY: So like your mother Cora...same pale skin...

black hair…

CORA: He comes at me for a bear hug and I… (*Change of atmosphere, as if she's talking through water, lights dim about her.*) slimy touching, can't breathe, big hands on my face and it's our little secret Cora, our little ssshhhhh…

COUGHASY/CORA: (*Beat.*) Our little secret –

CORA: I drop my ice-cream on the sand and I watch the brown cone crack and crumble, the ripple melt and flow, and I feel Mikey's cake in my tummy swirling and…I can't breathe, his hands are on my ribs, his words are on my skin, below my neck. He's lifting up my lace hem and talking talk I don't understand except the –

CLOUGHASY: Promise not to tell, promise Cora, promise not to tell, promise –

CORA: There's loads of ants in the ice-cream as my buttons come undone and I think this is what the devil Auntie Mary talks about feels like, when he comes for you, gets inside you and hurting and burning and the whole world is spinning with his grey heaving head against my shoulders and my lungs are all full of onions and antiseptic…and I wonder what Mikey is doing right about now with his cake in my tummy, all swirling and heaving and hurling and suddenly it all comes up, all over his expensive blue suit, and there's something like hate on his face as he swings and I'm crying and…

(*Scene change. CLOUGHASY is gone and CORA is centre stage kneeling/sitting facing the audience.*)

CORA: I could tell Mikey.

MIKEY: (*Talking to the audience, ignoring CORA but coming behind her and placing his hands over her eyes as he says the last line.*) Dr Coughasy said, when he brought her back, that they saw a man being killed by a bull on the way into the city… (*As if it's just dawning on him.*) …I thought they were going for ice cream and there was sand on Cora's shoes but anyway, he says she saw the horn push right through the ribs and lungs clear through to the other side of it. Must have been terrible. If I was there,
I wouldn't have left her watch it, I'd of put my hands over

her eyes like I do when we watch scary films on the telly.
(*CORA just looks at the audience. Scene change. CORA jumps suddenly and addresses MIKEY.*)

CORA: Just do it, Mikey.

MIKEY: (*Distressed.*) I can't, Cora.

CORA: Go on…Mikey, please.

MIKEY: It's wrong Cora, we can't, I won't.

CORA: Mikey now! Please, for me!

MIKEY: (*Looks at the audience.*) Cora wants me to…to…to take money from the till, to steal…she says if I do we can leave sooner, faster, but –
(*She turns her back and the conversation is one-sided, all we see is her back.*)
Cora, course I do but…stealing's not right…and I …no Cora…I know but…sure I do but…Cora…it's not right I… but…(*Beat. Hangs his head.*)
Yes Cora.
(*Switch back to MACCA who bursts aggressively on stage. Very defensive.*)

MACCA: Now usually…you know…I'm no snitch or nothing, I'm no rat…ask any of the boys, but as I was sitting in Moran's with a couple of pints and a couple of the lads, I was thinking about the whole incident and about what the hell they were running from, you know like? And the cash…the notes…I mean I'd no objection to it like but all the same…all the same…and as Sunny was saying, if they were messed up in something bad that meant that I was an access… I was an acommm… I was an associate… and then didn't Pauly O say that his girlfriend's cousin's uncle is a security guard in some bank in the city and that he had a friend who is a security guard in Thompson's, which is directly across the road from this small shop called Suzy's on the corner of Thistle Street and he said to Pauly's girlfriend's cousins… (*Fumbles.*) …anyway…that it was ripped off this afternoon by this young girl and a guy and that they were wanted in connection with something serious down the country and now stealing is one thing… but… (*Fumbling for words.*) that other business is a different story altogether…so I was really thinking of that when

I walked down to the station...that and the fact that the old lady from Suzy's was putting up a hundred pounds reward to anyone who knew anything about it...and I reckoned...I knew something...but ordinarily...I'm no snitch or nothing, I'm no rat.

(*MACCA backs away as we switch back to CORA, physical movement to suggest staring into mirror and the repulsion she recognises there before she begins. Both CORA and MIKEY talk to the audience.*)

CORA: I'm watching my reflection in the bathroom mirror. (*Pause.*)

The pearls of sweat on my collar bone from the heat of it all, the taste of salt above my lip, the trace of filth beneath my skin...and (*Pause.*) ...he won't come until after Holy Hour. The smell of Sunday roast brings me down the stairs and into the kitchen, where the Doctor sits with an easy arm about an easy pint. His car is red and glossy...the seats leather and deep. I think of the shoebox underneath the bed with our money for Dublin. He turns up the radio as we drive away.

MIKEY: There are two photographs on the mantelpiece in the back room off our kitchen. The first is of Uncle Dan, he is holding a hurley in one hand and a trophy in the other. Mrs Smith, who works in the kitchen, says he was an unbelievable player when he was young, played for the county and all, won matches all over the place. In the picture he is smiling the widest smile I've ever seen and there are people around him with their hands on his shoulders.

CORA: There's talk about the Doctor's wife and the man who works in the post office. There's talk of a new bigger pub being built down by the strand. There's Mikey's talk of leaving but we're still here. Talk is talk and I don't care either way as I steal a drag from Uncle Dan's Benson and I drink it back.

(*Beat.*)

Talk is overrated anyway and I hear enough of it from my bedroom at times when everything should be asleep and

not sitting by the window, listening to World War Three – erupting from the kitchen. She'll drive Dan to drink, Mikey says. I say he hasn't far to go.

(*Change to signal time has passed.*)

The Sunday roast is burned to the bone. Dan is in the back room with a bottle of Powers. Auntie Mary is away a lot with ICA functions. Outside the summer is heavy with mist and rain and I'm reading over and over again the postcard between my fingers that says Uncle Laurance has moved to London and how he hopes we're all well. Mikey passes through and I shove the card between the till and the wall. I'm alone when the Doctor arrives.

MIKEY: The other is this photo of Mam. She's in Dublin, surrounded by this huge crowd of people, standing on a summer's day, watching these men swim a race in the river that runs through the city. Big strong men with their shirts off getting ready for the race, and all the women watching on the bridge and by the street and my mother, eyes smiling with another girl and a tall man in a dark suit... Mam in a yellow dress...well it's a black and white photo but I'm sure it's yellow...should be...she looks like Cora with dark eyes and dark hair... I tell Cora when we go there I'll swim in that race and win too, and she can stand there on the bank in a yellow dress and –

CORA: I know he's staring at the base of my neck while I tilt the glass and wait for his pint to settle. My hand is shaking when I take the notes from his hand and I thank God Mikey's there, drinking coffee and doing the accounts and I'm just about to fly away upstairs when –

MIKEY: Dan calls me through to the back room. He wants (*Mimics him.*) a mug of tea, well-sugared and hot, and bring us another bottle from the bar, Mikey, there's a good lad... to warm the bones you know...

(*Back to himself.*)

It's July and it's warm enough but I bring it through anyway while –

CORA: I'm pouring a pint for myself.

MIKEY: And I'm just in time to catch sight of that box of empties he thinks we don't know about but we do, we just

pretend we don't.

CORA: And I'm waiting and thinking and wondering...
 waiting and praying and shaking as he finishes his pint –

CLOUGHASY: It's cold enough out there today, Cora.

CORA: Is it?

CLOUGHASY: Oh it is, it is, (*Beat.*) you might need your
 jacket, Cora...

CORA: (*To the audience.*) Out in the car, and this time it's
 whiskey, just a little at first, then down my throat like fire
 hot tea.

(*Switch to MIKEY and CORA talking to audience.*)

MIKEY: Dan says thank God it's December because –

CORA: Tourism is spreading like the plague.

MIKEY: The place isn't the same, locals drink at home in
 the summer months to avoid the bus loads of Yanks and
 camera flashes and Auntie Mary left two months ago for a
 weekend retreat in Lough Derg.

(*CORA turns to MIKEY.*)

CORA: It's time to go, Mikey.

MIKEY: Sure sure.

CORA: (*To the audience.*) The next time...next time he pushes
 through the door...the next time he –

CLOUGHASY: Hello there now and –

CORA: (*Back to MIKEY.*) Tonight so, yeah? Tonight?

MIKEY: Sure sure, (*To the audience.*) and I don't mind cos' this
 place is rotting away, and I'm thinking of the clean break
 we're going to make and of the city at our feet.

CORA: I'm sitting at the window when I see the tour bus
 pull up outside and thirty shiny Yanks climb down the
 steps and into the hostel across the way. There's only me
 at home, and I'm not supposed to open up the bar on my
 own, but it's been so quiet and business so bad and...I see
 most of the crowd move down towards the Bay View hotel
 and I sit behind the counter and wait.

(*Sits for a second then looks suddenly to her right, blushes, and
turns back to tell the audience.*)

He comes through the door with a friend and they want
two Guinness (*Steals another look and this time smiles and looks
bashful.*) he looks like some movie star in those black and

white films Mrs Smith watches and...
(*Steals another look.*)
I didn't know people could smile like that...and he smiles
at me all sweet with blue blue eyes and (*Terror.*) then the
crowd surge back up the street and into our pub cos' the
Bay View is closed on a Monday and suddenly it's all –
(*The two lads step forward as American tourists.*)
FIRST TOURIST: ...aaaaaawwwwwwwmmmmmmmm...
three guinness, two G and Ts, four brandies...you got diet
coke?
SECOND TOURIST: Three pints of lager...you got
Budwiser?
FIRST TOURIST: ...aaaaaawwwmmmm...hold on a second
I've forgotten what the little lady wanted.
(*Laughs, and yells at his wife, roaring into SECOND
TOURIST's ear at the same time.*)
Honey...aawwww, HONEY...did you want a whiskey
straight...haw haw...just kidding...she's a TT, you know...
used to be a bit too keen on the old juice –
SECOND TOURIST: Three coffees, but only if you have
non-fat decaf, otherwise we won't touch the stuff, and three
Jack Daniel's... (*Two look at each other, then say together.*) or
John to his friends... (*Laugh.*)
(*Snap back to CORA.*)
CORA: – and it's hell, pure hell, but blue eyes is still at the
corner and he's been smiling that smile at me all night...
(*Lights fade down.*)
The crowd surge out and I'm drinking my pint and reading
the paper when he comes back through the door. (*Pause.*)
We talk like friends do.
(*Bashful.*)
He thinks I have pretty hair. And after closing time and
the town is dozing we trickle down to the shore all warm
from the stout and his hand on my shoulder, and I forget
we're here, in this hole, and I forget about Mikey and the
shoe box for Dublin, and the Doctor with his dark lazy
touching...and...
(*Lights very dim. Up slightly on CORA and DOCTOR.*)
CLOUGHASY: (*Drunk.*) Cora.

CORA: (*Terrified.*) Sshhh...ssshhhhhh...

CLOUGHASY: Cora...I know you're down here... Conor
Doyle saw you...Cora.

CORA: (*Rocking.*) Sshhhhh...sshhhhhh.

(*Stands and walks forward to the audience, blunt manner.*)
Blue eyes lasted about five minutes, not that I can blame
him, the Doctor came at him all elbows and knees fighting
dirty and he ran like a child away and I...same story
different night, except this time, he caught my face with
a fist that was meant for the Yank and it's this time, and
it's all like a map in my head, each part marked out like a
journey.

(*Change. CORA switches to wide eyed innocent character,
while pleading with MIKEY, then back to harder character
when talking to audience.*)
You have to Mikey, you have to...please...please...look
how hard he hit...look...look (*To audience.*) and I don't tell
him the full story...cos'... (*Pause.*) because...I can't...
I tell him enough...and I tell him where I left him down
on the strand...and I sit and wait and imagine it's me gone
down there...with that knife Dan uses to open oysters...
down below with the ice creams of my childhood in the
sand beneath me, and there among the pebbles and the
grit and the crab pools, I'd...push it through...like he did...
once for every year he treated me for my birthday.

(*Scene change. MIKEY alone, dimly lit.*)

MIKEY: I can't see anything at first, it's dark like pitch and
the sea breeze has salt in my eyes and mouth...can't see...
I turn down towards the dunes and I'm just about to give
up...when I see this heap of darkness on the sand. He's
only half dressed, with his suit trousers around his knees
and he wakes and recognises me and I'm about to do it,
I am...but I can't.

CORA: (*From behind, echoing the earlier conversation.*) What do
you mean you can't?

MIKEY: I'm thinking of heading back and telling her I did it
anyway and we could leave tonight and who would know?
But what she said he did...what he did...I toss the knife
away and make him walk with me up towards the cliff
side...it's easier...one push...

(*Scene change. Bright general wash. CORA steps forward.*)

CORA: Afterwards in the pub, I hear Mrs Smith say –

MIKEY: (*Mimics Mrs Smith.*) It's a terrible thing… terrible…
such a good and decent man…such an honourable and
hard working man…always a kind word…wasn't I just
saying to Bridie Farrell around the corner, he was the kind
of man we could look up to…and an educated man…
knew all about geography and history…and languages…
'twas that wife of his finished him off sure, running off with
that young one…she'll get her comeuppance…what goes
around comes around…and always had such great time for
the children… (*Back to himself, upset.*) …for the children…

CORA: I make the sandwiches and Mikey passes them
around. Outside the ocean is still as milk and even Dan is
upright and pulling pints for the mourners who crowd into
our small pub. Mikey is so pale Timmy Ryan asks him
what's wrong and if he was coming down with something
and Mikey starts to choke on the chicken sandwich he's
eating until I tell Timmy how close Mikey and the Doctor
were before he died.

(*Waits for a reaction from the audience, then is put out when she
doesn't get one.*)

Well, I think it's bloody hilarious but Mikey starts to choke
even harder and he almost passes out on the floor by the
cigarette machine… 'Tonight', I promise him, 'tonight.'

(*Cut to MACCA telling his story to the Gardai.*)

MACCA: It's just like I said, Sergeant, the big rough guy
threatened me, with…with…with…this gun he was
carrying…said he'd shoot a hole right through my head…
bammmm…so I was scared Sergeant…not only for myself
you understand…no no…Macca knows no fear…but for
my sick mother who depends on me so much in her final
days…

(*He's thinking, pause for effect, then continues.*)

So anyway…minding my own business I was…on my way
down to the shelter for the homeless where I do volunteer
work, when he grabs me and threatens me that if I don't
go with them he'll shoot me there and then… bammm…
straight through the head…bamm…so – 'Hold on, hold

on,' I said, 'Take me and my money, but please don't hurt
these innocent women and children,'
I said. But he wasn't having any of it, Sergeant, he pointed
that big barrel, at least I think that's what it's called, right at
my head, so you see I was no accom… accom…accom…
associate of theirs Sergeant…no no…and then, then he
forces me to stand there and watch while he needlessly
and viciously attacked that poor law enforcement officer…
just jumped him out of the blue… left him bloodying the
pavement, Sergeant…bloodying the pavement…
(*Cut to MIKEY and CORA, lights down, faces barely visible.*)
CORA: I've sent Mikey through to the kitchen, he's packing
up the stuff so I'm left to put Dan to bed. He's sitting on
the chair in the back room, grey and trembling, fumbling
with his cufflinks and trying to smile at me the way he did
when I was six, and he was teaching me how to pull a pint
of stout, balancing me on the beer crate, his hand around
mine around the glass. The shake in his hand is getting
worse as he's trying to untie his tie.
I push his hand away and I'm ripping the knot, when he
reaches out to touch my face and tell me how much
I look like my mother. I tell him we're leaving…he slides
from the chair on to the wooden floor with his head against
the bed. I feel like a soiled version of the statue of Holy
Mary we have in our kitchen downstairs. All in white, with
a man kneeling at my feet. I pour him a large one leave the
bottle by the bed and shut the door, Mikey is –
MIKEY: – at the door, waiting. I'm nervous.
(*Paces.*)
In through the window the bar is crumbling.
(*Paces.*)
There hasn't been a stock delivery in two months, they
won't come until he pays the unpaid bills he can't pay, and
here we are, and sure sure, we're set up, we're sorted, but
what about Dan? We can't just…
CORA: (*To the audience.*) It's time to go…at the bus stop…it's
cold…
MIKEY: (*To CORA.*) Cora?

CORA: Yeah?

MIKEY: Did you notice the way Johny Kelleher wasn't at the funeral?

CORA: What? Sure he was, everyone was there, he was up the front with Timmy and –

MIKEY: No, I mean he wasn't at the pub afterwards...

CORA: Oh...you sure?

MIKEY: Positive...

(Pause. Wait for reply.)

...don't you think it's strange?

CORA: I dunno really.

MIKEY: You don't think maybe he –

CORA: Look, here's the bus –

(To the audience.)

The bus journey is slow and solid and we're both wrecked tired, the driver is small and bald with a cowboy hat and he whistles the theme tune from Dallas over and over again. Mikey is asleep before we leave the village and I drop off soon after...we wake to the driver leaning over us, shaking us, telling us we're there...we're here...we step off the bus and run as fast as we can, running until we reach the river and –

(As if they can see it before them.)

MIKEY: Dublin.

CORA: Dublin.

MIKEY: *(Disgusted.)* Dublin?... Is that the Liffey? Sure you couldn't swim in that, could you?

CORA: *(To audience.)* All around is grey and smoke as we head deeper into the city and even with the Christmas lights and decorations it's still all shadows...but straight ahead is MacDonald's and we sit on the step until it opens and we dive for the counter.

MIKEY: *(To imaginary person at counter.)* Two quarter pounder's with cheese, two large chips and two large cokes please...

CORA: *(To audience.)* And in two seconds, it's there in front of us, steaming and the smell of chips and burgers going into our lungs and I...

(To MIKEY.)

Pay the man, Mikey.

MIKEY: Can I've some salt with that?

CORA: Pay the nice man, Mikey, come on...

MIKEY: What? But...

CORA: But what...pay the man I'm starving...

MIKEY: I... (*Remembers.*) oh...Cora...I...

CORA: What Mikey, you didn't forget, you couldn't, don't say you...

MIKEY: I left it –

CORA: You couldn't have you just...

MIKEY: Dan, Cora, couldn't leave him with nothing could we... I'm sorry Cora.

CORA: (*Back to the audience.*) And as fast as the food was there, it's gone and we have to watch some small fat guy devour them as we sit outside and –

MIKEY: It's all right, Cora, all we have to do is head for Uncle Laurence's, he'll sort us out, he'll –

CORA: We can't go to Uncle Laurance's...

MIKEY: Why not?

CORA: Because –

(*Back to the audience.*)

And I tell him and he shouted and screamed and kept saying 'what are we going to do?'

MIKEY: What are we going to do?

CORA: What are we going to do? Over and over again. It started to get cold, we moved deeper into the city until we were standing at the top of Grafton Street. I've never been so hungry...

MIKEY: (*To audience.*) The place was alive with people, all dressed up and drinking and, most places were closed except for this small shop, with 'Suzy's' written in pink over the doorway...

(*Pause. Looks at CORA protectively.*)

It was my idea...

CORA: No it wasn't, it was mine...

MIKEY: At first, we were just going to take some food, some bread or something.

CORA: But then I figured if we got enough, we could be in London by tomorrow, and the plan was so simple...

(*Light change to harsh whites as both jump forward at the audience.*)

MIKEY: Straight in fast and angry and (*Shouting.*) 'Cora, shut the door!'

CORA: Mikey goes straight for the woman behind the counter with his hand under his shirt and –

MIKEY: 'Open the till, open the fucking till…'

CORA: And what a gift, she had all the Christmas takings in the safe below the counter…over three grand…

MIKEY: 'We don't need that much do we…do we?'

CORA: Of course we do…hurry up.

MIKEY: I tie her to the chair and –

CORA: I empty my bag and 'come on…come on' and –

MIKEY: We're shoving handfuls of it into our pockets and –

CORA: 'Mikey she's moving' and –

MIKEY: I turn and strike…

CORA: She falls hard and –

MIKEY: Shit.

CORA: Shit.

MIKEY: Shit…I didn't mean it…didn't mean for it to be so… shit.

CORA: 'Come on Mikey'.

MIKEY: 'But she's not moving, Cora.'

CORA: 'Out the door, Mikey…out the fucking door.'

MIKEY: Flying down Grafton Street…

CORA: Looking for the turn off…

MIKEY: Flying flying…

CORA: 'It's off Golton Street…ask someone…ask anyone…'
(*Switch back to MACCA.*)

MACCA: So I begged them, 'turn yourselves in, lads,' I said, 'crime is not the answer to your problems, love is'…but they were having none of it…none of it at all, Sergeant. It broke my heart I tell you…and – sorry? Oh how did I? Ammmm…I fought my way out of there, Sergeant… though he was a big guy…broad…big arms…angry… and she was a nasty piece of work, I tell you…violent enough like…but I can look after myself and I got him a right good one, straight into the face and down… (*Catches himself.*) …now I don't like violence myself though…but it

was self-defence...the gun? Ohhh...he had put it down... yes he had put it down and was having a rest for himself when I took my leave and came straight here...straight to the station, Sergeant... straight down... What is it they are wanted for anyway Sergeant? That is if you don't mind me asking...

(*Registers shock. Has to sit down.*)

You mean I was...I could have been... What sick minds... sick sick sick... I'll tell you now, Sergeant...there's something not right about those two...touched they are... twisted sick and touched... I'm lucky I'm not sitting here dead...

(*Back in the shelter, dim lights, dull blue was with faint white spots on each.*)

MIKEY: What if someone knows?

CORA: No one knows.

MIKEY: What if someone saw?

CORA: No one saw.

MIKEY: What if – ?

CORA: No one knows and no one saw...

(*To audience.*)

Dublin, thirty-first of December 1999, it's about ten to twelve and I'm sure I can keep Mikey's doubts away, at least long enough for –

MIKEY: (*To audience, nervous, scared, it's hard to talk.*) – Timmy Flynn told me once that in Barrymount jail, all the city crowd hate the country crowd, they have this big gang and they do terrible things to them...

(*Voice gets quieter.*)

The cells are damp and cold...and you can't see the sky... only grey black ceilings...and the guards, the guards carry metal rods and they feed you to the big psycho guys if you piss them off and...

(*Pause.*)

I hit a Garda pretty hard, didn't I. (*Childlike.*) I don't want to go to Barrymount...I didn't mean to hit so hard, I really didn't. And I don't like Dublin, I want to go home...I just want to go home...

(*Switch to MACCA, talking to the audience.*)

MACCA: I swear to God, lads…no word of a lie…here
I was…New Years Eve…in Tivoli Station with twenty
fucking pigs and not one pint in me, below answering the
same questions for half the evening, when I could have
been drinking with the boys in Moran's …anyway…
statement after statement…and I told them again and
again…forty fucking times, before they loaded me into the
squad car and we headed for the shelter…it was coming
up to twelve now and the streets were jammed…and here
I was, all squished and squashed, hoping I'd make it to
Moran's in time for last call. And just as we were pulling
up to the shelter, didn't it ring twelve. Could you believe
it? The first minute of the year 2000, and me, sober as a
judge, singing Auld Lange Syne with the boys from Tivoli
Station.

(*Switch.*)

CORA: Time to go.

MIKEY: Why don't we just go home? Let's just go home,
Cora…

CORA: Mikey, half the city is out looking for us…

MIKEY: I know, but I'll explain and –

CORA: Do you think they don't know?

MIKEY: I'll explain, I'll –

CORA: They know.

MIKEY: I'll say the shop was my idea, that it was an accident.

CORA: Barrymount, Mikey.

MIKEY: No, Cora.

CORA: (*Screaming.*) Out the door.

(*Switch.*)

MACCA: Anyway, I was thinking what I'd do with the extra
cash, and I couldn't believe I'd made six hundred in
one day…and I had the dole cheque coming to me on
Thursday…in my element I was. And 'this way, lads'
I said, and they all plodded after me, and I felt a hint of the
rush that I had had earlier on, as I pushed open the door
and –

(*Switch.*)

CORA: London's only a few hours away, oh come on, it will
be sweet…

(*Gets angry.*)

Come on Mikey, out the door, out the fucking door, come on we could be –

MACCA: Gone…could you believe it? Would you fucking credit it? Gone I tell you…without a trace…which meant that I was back down at the station within the hour giving the same statement over and over…and I didn't walk out the station door until ten o'clock the next fucking morning, with no hundred pounds to show for it…and straight down to Moran's where Sunny and the lads were on the cure and we drank the night away…and the next one…until I woke up three days later with fifty pence to show for the five hundred I'd made on New Year's Eve…taught me a lesson about snitching though… about country people… they seem all quiet like, you know? But they're all fucking twisted…especially those two…touched and twisted… I tell you…touched and twisted.

(*Pause, regains his composure, straightens his shirt.*)

Anyway… (*Smiles.*) you coming for a pint?

(*Sharp blackout. Music up.*)

The End.

BLUE

This play is dedicated to

Jim O'Loughlin
(1903–2002)

for enchanting me with words a very long time ago

...missed with a grief beyond all tears...

&

Nora O'Loughlin

for the brown bread and the soup and all things nourishing

Characters

DES
late teens, the quiet one, the thinker, the peace keeper

JOE
late teens, big mouth, hard shell, soft heart

DANNY
late teens, seems younger though, tom boy

The action takes place on three levels of staggered height. The highest level represents the cliff top. In the original production the drop from this level to the floor was quite significant and reminiscent of a cliff edge. The actors must be able to move from level to level with ease. Alternatively, a very minimal setting would also work. A dense soundscape and an intricate lighting design were used to create a vibrant atmosphere.

Blue was commissioned by the Cork Opera House in 2000 and was first performed in the Half Moon Theatre in June 2000, with the following cast:

DES, James Donnelly
JOE, Kevin O'Leary
DANNY, Dorothy Cotter

Director, Ursula Rani Sarma
Production Manager, Joe Stocktale
Set Design, Cliff D'Olliver
Sound Design, Cormac O'Connor
Stage Manager, Paul MacCarthy

Blue was first performed in Britain at the Latchmere Theatre, London on 19 November 2002, with the following cast:

DES, Aidan O'Hare
JOE, Kevin O'Leary
DANNY, Corrina Cunningham

Director, Joss Bennathon
Set and Costume Design, Jens Demant Cole
Lighting Design, Guy Hoare
Sound Design, Jim Turner

ACT ONE

Scene 1

Sound FX: Waves crashing, seagulls. Actors walk on stage in darkness. DES goes to the highest level, DANNY and JOE kneel together on the bottom level. When in place, the waves increase in volume, then drop away suddenly. Stage still in darkness except for blue ripple light which fades up on DES.

DES: In my dream,
 I am standing at the edge of the cliff,
 it's dark, the sky is heavy and grey.
 The sea is wild.
 I'm looking out over the Atlantic and she's like tinfoil, with lace at her ankles in waves on the shore.
 Out by the point, she's curling and furling and waltzing with the surfer boys down from the city.
 She's a cradle,
 She's a mercury blue duvet and as I step out onto the air,
 She's a soft wall flying up to meet me and I'm through,
 And I'm going way down into the blue like lead.
 Swift, swept, stung under…
 Pulled, pushed, pant, under…
 Feel the wishy water pulse past in the grandest wet embrace,
 And it's all a womb down here.
 All so smooth down here,
 Smooth to be pulsing through and
 Such a fear is this,
 To feel the ocean lock fingers with you
 like some dark friend you forgot to lose.
 Like stones pulling me down and I have forgotten how to breathe.
 No need down here,
 No noise down here,
 only rhythms and sighs.

(*Stops and smiles, calmer now.*)
Thousands of shell voices exhaling waves onto the shores
above.
And as I drop further the bottom of the ocean rises up to
touch me,
and it's a night sky,
black sand flecked with stars,
and I touch down and the sand is warm and deep.
I reach to touch a star and see that it's a diamond,
they're all diamonds,
(*Picking up the pace again.*)
I try to pick them up but they're too heavy,
all the size of dinner plates
so beautiful,
and I lie face down in the deep black sand and
open my mouth and breath in the blueness,
touch the stars that are diamond cool and smooth in my
hands.
And I hear her call my name,
Look up to see her gliding towards me,
So beautiful like she belongs here,
and she walks and talks with me,
and everything is wonder and grace...
But she walks away too soon –
Always too soon,
Away across the black sand,
Careful to step about the stars.
Can't you stay?
Stay a while longer,
I'll be a good boy,
Stay...

Scene 2

Lights cross-fade smoothly to DANNY and JOE as sounds of church
bells are introduced, DES is left standing on higher level but in
darkness. DANNY and JOE become animated when lights are
up on them fully. They kneel suddenly, hands clasped before them.
They are seven or eight, at church for DES' mother's funeral. JOE

is falling asleep, DANNY very nervous. They stand and DANNY fixes JOE's shirt and they come forward to centre. They come forward in turn and speak to an imaginary DES.

JOE: Sorry for your troubles.

DANNY: Sorry for your troubles.

JOE: My Mam said for me to say that but I don't really know what it means.

DANNY: It just means that you're sad that he's sad.

JOE: Oh…good then…I never saw no one dead before…

DANNY: (*Corrects him.*) You never saw anyone.

JOE: Nope, not once…never…no one…I mean…she looks good your Ma… I thought she'd be all shrivelled and… (*Shakes his hand again.*) Sorry for your…well… Want to play marbles, my Ma bought me a new bag of bull's eyes?

DANNY: Want to play football? We could go outside.
 (*Pause.*)
 Okay, bye so, see you tomorrow? (*Turns and walks away, stops when JOE speaks and looks back at him.*)

JOE: I'm sad that you're sad.
 (*Pause.*)
 You know you can come over and see my Mam whenever you want?
 (*DANNY walks forward and takes his hand.*)
 Right so.

DANNY: Right so.

JOE/DANNY: (*Together.*) Bye Des.
 (*Both turn and head towards second level.*)
 (*Cut back to DES.*)

DES: I remember white hands,
 soft hands,
 hands like pearls and low laughter and her smell.
 Can't you stay?
 Stay a while longer,
 I'll be a good boy,
 Stay.

Scene 3

Blackout. Lights up on level three, blue sky, sound of ocean in distance, seagulls etc. DANNY is stage left, sitting, trousers rolled up, legs dangling over edge, her back to the boys. DES is sitting also, staring out towards the audience. JOE is behind them, pacing, agitated, very nervous. Trying to speak for a moment, starts and stops, then bursts into speech.

JOE: It was all right wasn't it?

> *(No answer.)*

> I mean it could have been a lot worse, I think anyway, I thought it would have been an awful lot worse. It could have been couldn't it? Des... Des!

DES: What?

JOE: I said it could have been worse couldn't it?

DES: I suppose Joe.

JOE: *(Awkward.)* It's funny you know, haven't been to a funeral since your Mam's, well not funny but, well...Mrs Nagle was in a bad state...I suppose it's very sad really. Did you see Mr Casey there?

DES: I did Joe.

JOE: Christ he brings that metre stick everywhere with him, it's like it's attached to his arm or something, it's not normal, always in his hand, leaning on it or chewing it or tapping it off something, it's weird isn't it, just not normal at all...and was that his wife? I didn't even know he was married, to be honest I thought maybe he was a bit of a girly, but that one today, Jesus she's more of a man than he is, face like an elephant's arse, did you see her Des?

DES: I didn't Joe.

JOE: Well, you're better off, no one needs that sort of image in their heads, give you fucking nightmares and the voice off her, you must have heard her on those halleluiahs, Des, you must have, she was belting out those hymns like her life depended on it, my fuckin' ears were in agony, at one stage I was convinced if she opened her mouth to break into one more bloody chorus I swear to God, I would have taken that metre stick off him and shoved it right up her –

Des Foley are you even listening to me?

DES: 'Course I am Joe.

JOE: I don't think you are you know, I think you're sitting there with your eyes open and your ears closed. Do you hear me?

DES: 'Course I do Joe.

JOE: (*Gives up and sits next to him.*) Can you imagine it? All those people standing there around her on the ground, except Casey of course, Casey probably wouldn't have batted an eye, just given me lines or something.

(*Laughs.*)

I must not ram metre sticks up other people's bottoms... hundreds and hundreds of them...

(*Laughs more, stands, puts out his cigarette, turns and looks at DES.*)

Des.

DES: Yes Joe.

JOE: (*Awkward.*) Are you very angry with me?

(*No response.*)

You are aren't you? I guess I don't blame you if you are, but I...

(*Pauses. Then rushes on.*)

Look you know that I never meant...you know I never would have, look Des you – I just –

DES: I'm not angry with you.

JOE: You're not?

DES: No.

JOE: Are you very sad then?

DES: I guess I feel...I feel... I feel kind of dead on the inside.

JOE: Right...

(*Pause.*)

I think I do too, at least I have this sinking feeling in my stomach...

(*Wants to say something but can't.*)

Des... I...

(*Stands and walks away from him, turns.*)

Did you see Derek Mulvey up the front, grinning he was, I swear it he was grinning, you should have seen him,

smirking away, he shouldn't have even been there, poor
Danny. Mulvey was delighted I tell you, delighted I swear,
never saw him looking so bloody happy…

DES: Joe.

JOE: What?

DES: Could you shut up for five seconds you're making my
head hurt.

JOE: Am I?

DES: Yeah you are?

JOE: Sorry…

(*Waits for a second.*)

Who were that couple in the front row with the roaring
baby? Didn't recognise them at all… Christ have you ever
seen such an ugly child?

DES: Aunt and Uncle from Dublin.

JOE: Absolutely roaring his head off.

DES: Her.

JOE: But then I thought it was good that he was crying, 'cos
no one else was.

DES: She.

JOE: And I just thought, you know, at least someone was. My
Ma says, a funeral without tears means the person won't
be missed and that at least one person should cry at every
funeral, even if he was ugly as the back of a bus and he
didn't know what he was crying for.

DES: It's a she.

JOE: What is?

DES: The baby it's a she, the christening was in November,
they asked her to be godmother, I went up with her.

JOE: (*Offended.*) When was this?

DES: I just said, November.

JOE: Why didn't ye tell me?

DES: 'Cos we didn't.

JOE: I'd like to have gone too, ye could have told me, why
didn't ye tell me, Des?

DES: We just didn't, could you be quiet for a while.

JOE: But why didn't ye – just –

DES: (*Shouting.*) Because sometimes, you can be an irritating
bastard Joe, now just shut up for a while, can't you.

(*Cut to flashback, lights up on DANNY, fade down on others.*)
DANNY: What if I let her fall Des? But what if I do Des?
What if the priest makes me hold her and my hand slips
and she falls and it kills her then and she's lying there dead
and it'll get blood all over my new blue dress…and ohhh,
my Aunt would kill me, stone dead she'd kill me, cut me
up into little pieces with her sewing scissors. I'd have to run
away, I'd be a convict, I'd have to escape and stow away
on some ship that's going to a foreign country where the
sun shines on the beaches all the time and all I'd do is walk
up and down those beaches and swim and feel the deep
heat on my face and…
(*Pause.*)
I'll never be able to come home ever again… I'd be an
exile in a foreign land, destined never to touch the earth
of Ireland, I could die my hair blonde and change it to
something elegant…like…like…like Demi or Nicole or
Marylon…
(*Big sigh, closes her eyes, loses herself.*)
I'd say the water over there would be warm as toast, I just
bet you, and jumping in would be like…would be like
climbing in to a huge big watery bed that had an electric
blanket heating it all day long…
(*DES shakes his head.*)
And imagine the colours of the fish, like the ones on the
posters you have in your room at home – beautiful fish
every colour you could think of. And you could stay in the
water for hours and not be cold…couldn't you? It would
be like a great big bath.
(*Pause. Another sigh.*)
And you'd come and visit with me…over there…to the
beaches, and Joe, if he behaves himself, Des, would you?
We'd have a great time… Would you come then?
(*Softly.*)
Come with me. You would? We could go out to Greece
and visit Jack Mayol and sit on his veranda and drink tea
with him. Iced tea though, 'cos of how hot it would be, and
he'll show us his medals and trophies and we'll talk about
the weather and say 'Yes Jack' and 'No Jack' and 'Isn't that

interesting Jack' and he'd take us out on his white boat, out on the sea and you could dive right in and not come up for hours and hours. And I'll sit on the deck and sunbathe until these pasty chalky legs are brown as chocolate...oh and dolphins...

DES: Hundreds of them...

DANNY: Like Flipper.

DES: Better than Flipper.

DANNY: Better than Flipper.

DES: Yeah, Flipper was crap.

DANNY: (*Not too sure.*) Yeah...oh would you really come see me Des? All the way over there?

DES: Course I would.

DANNY: Really Des?

DES: Really Danny...'cos we're...you know...we're friends.

DANNY: Oh...yeah...that'd be...you know...friends.

DES: Friends.

DANNY: Friends.

> (*Sighs. Pause.*)
>
> What if I trip and the baby, she falls right out of my hands?
>
> (*Lights fading down on her.*)

DES: Danny.

DANNY: I'm just saying...it could happen,

> It could happen,
>
> (*Closes her eyes and sighs.*)
>
> And you'd come with me,
>
> (*Softly.*)
>
> Come with me.
>
> (*Switch back to DES and JOE.*)

JOE: Des what was their second name again, wasn't he German or something, some awful funny last name?

DES: I dunno.

JOE: (*Laughs.*) Remember we were laughing so hard at practise you went under and my Da made Danny give you the kiss of life.

DES: I don't remember.

JOE: Yeah you do...you snogged her, you snogged Danny.

> (*Laughs.*)

DES: Shut up, will you?

JOE: What was the name? It was fucking appalling...it's weird

they wanted Danny to look after the kid if something happened them, with her mother and all.

DES: Leave it.

JOE: I'm just saying, she could've gone completely nuts in time.

DES: It's not like that Joe.

JOE: Like what?

DES: It's not like the colour of your hair, you don't just get it because your parents had it.

JOE: Yeah you do, it's in the genes apparently, and if her Ma has it then there's a good chance Danny could have.

DES: Well I guess that means you'll be as big an asshole as your Da then.

JOE: What?

DES: Well if it's in the genes like you say…

JOE: (*Thinks about it for a second.*) Oh… (*Nervous laugh.*) Yeah and I guess you'll be spreading slurry for the rest of your life.

DES: (*Angry.*) Why you always saying the most stupid things Joe? It's like you handpick them every fucking morning or something, like you chose the most stupid comments to piss everyone off from a list every day, can't you give it a rest every now and then? Just shut the fuck up for five minutes and give it a rest?

(*JOE says nothing, stares at the ground.*)

JOE: Sorry.

DES: Doesn't matter…really.

JOE: I'm not stupid, Des.

DES: I know.

JOE: Or I don't mean to be.

DES: It's your timing, you know?

JOE: I know.

DES: You have the worst feckin' timing.

JOE: I said I know.

(*Pauses. Tries to make light of it although it has upset him.*) Remember when I walked in on Da and Mrs Dywer? He just looked up from her, still panting and sweating and said 'you have the worst feckin timing Joe' just like that, remember I told you? Remember?

55

(*Sound FX. Fade into flashback, perhaps voices pre-recorded, change of mood setting. The boys are very young, JOE is very upset.*)

DES: You okay Joe?

JOE: (*Crying, though pretending not to.*) Go away.

DES: Do you want to talk – to tell me – you can if you want you know?

JOE: Go away I said.

(*Goes for him.*)

Go away or I'll thump you, I'll...

(*Sits, crying. DES walks over and sits beside him, puts his hand on his shoulder.*)

I'll thump you...

(*Revert to conversation.*)

DES: I remember, we let all the air out of her tyres.

JOE: I know.

(*Pause. Decides to ignore it.*)

Jesus you're as grouchy as a big old bear this morning. I thought you had to be a grown up to be a godparent anyway...

(*Pause.*)

What was the father's name again...?

DES: (*Resigns himself to the fact that JOE is not going to shut up.*) The German guy?

JOE: Yeah...remember it was something like Dunker or Denker or?

DES: Boner or –

JOE: No no, far worse.

DES: Bender?

JOE: No no...ah.

(*Falls around the place laughing.*)

I have it...

(*Laughs again.*)

Wanker, remember? Mr and Mrs Wanker.

(*Two of them fall around the place laughing.*)

DES: And then...remember the baby... (*More laughing.*) Willimena...

JOE: But Danny pronounced it...

Scene 4

Sound of someone splashing into a pool and lighting change.
DANNY leads the way walking past JOE and DES to level two.
They follow her in disbelief.

DANNY: Wellima.

JOE: WELL I'M A? That's not even a name!

DANNY: Of course it is, it's her name.

JOE: It doesn't sound like one.

DES: It really doesn't.

DANNY: I'm telling you it is.

DES: Danny, are you sure it's not Wilhelmina?

JOE: Hang on hang on, this is the German family right?

DANNY: My aunt is Irish it's her husband that's –

JOE: Are you telling me, that for the rest of that child's
 natural born life, she has to introduce herself as 'Well I'm a
 Wanker'?
 (*JOE and DES fall around laughing. DANNY freezes.*
 DES jumps to the bottom level and talks to the audience followed
 by JOE as he says his first line.)

DES: And I laughed so hard I thought my stomach would
 explode.

JOE: All the time, shaking, laughing, laughing.

DES: All the time I could see him coming closer.

JOE: Coming nearer.

DES: But we couldn't stop we just had...
 (*DANNY on level two becomes Mr Leary.*)

DANNY: (*As Mr Leary.*) Something you might like to share
 with the group gentlemen?

DES/JOE: (*Take a step back together, look at each other then face*
 forward.) No sir.

DANNY: (*As Mr Leary.*) No pearls of wisdom to pass on? No?
 How about you, Mr Foley? Nothing at all? I could have
 sworn I was not the only one talking? Do you think I am
 hearing voices, Mr Foley?

DES: Yes sir.
 (*JOE hits him.*)
 I mean no sir.

57

DANNY: (*As Mr Leary.*) You're quite sure my sanity is intact?

DES: Yes sir, definitely sir.

DANNY: (*As Mr Leary.*) What about you Mr Leary, something funny to share?

JOE: No sir, I swear sir, it was nothing, sir.

DANNY: (*As Mr Leary.*) You are pathetic Joe Leary, what are you?

JOE: Pathetic sir.

DANNY: (*As Mr Leary.*) Well we don't want pathetic people here do we, Mr Foley? I said do we, Mr Foley?

DES: I dunno sir.

DANNY: (*As Mr Leary.*) I'd believe it, Mr Foley, in fact I'd say your knowledge is fairly limited...
(*Pause.*)

DES: I'm thinking how much I'd love to.

JOE: Rip that smile off his pasty white face.

DES: Knock him right down off his high fucking horse.

JOE: Push my fists deep far into his flesh.

DES: Until he sees things –

JOE: – until he sees things my way.

DANNY: (*As Mr Leary.*) The toilets need cleaning boys, you up to the challenge?

DES/JOE: (*Look at each other and then at him.*) Yes sir.

Scene 5

Lights fade down to dark blues. DES and DANNY head up to the cliff. JOE goes to follow but thinks twice before joining them and jumps back to level one and talks to the audience. A spotlight snaps up on him as he lands. This is JOE the showman, confident, cocky, loving the attention he knows he has.

JOE: 'The rest of the world could set itself by the way the day goes in this shagging place', by Joe Leary.
(*Clears his throat.*)
Look at us, we live just like the hands of a clock, every day we do the same things, wake up, go to school, go to swim practice, get yelled at by my Da, up here to the point straight after, listen to Danny moan about jumping off,

jump off, go home, eat dinner, pretend to study, go to bed. Friday nights we go into town, Saturdays we watch videos in Danny's house and Sundays we play PlayStation in my house. And it's just...well it's so boring, but there isn't anything else to do, we're probably the most active people in the whole shagging town, everyone does the same thing minute by minute hour by hour...that's why you could set a clock by this place.

We didn't think it was so bad to be doing the same things for the past seventeen years 'cos we didn't know any better. We've been isolated from the rest of the universe, it's like a bloody third world down here.

We might as well be in feckin Calcutta, you know my cousin Dave in Dublin? He had a choice of twenty-three subjects for the leaving last year and they went to Croatia on their school tour, we have to do the eight we're told to do and we go to Bunratty Castle on our tours. The cinemas and the clubs and everything...they have loads of things to do.

And what do we have...we have the Atlantic...and fair enough, they don't have the Atlantic, but for me, for a chance to get a slice of the bigger something, I'd trade her for that bit of excitement any day, any day.

Right so.

(Stands and turns to an imaginary string of cattle and begins.)
Ladies and gentlemen, observe if you will the double twist with the one half backward tumble performed by none other than our very own, Daniella Buckley.

DANNY: I'm not going first and it's Danny Buckley, Joe, Danny, how many times have I to tell you don't call me Daniella.

JOE: Apologies Daniella, forgive me ladies and gentlemen, I hope we have not put you off your meal of the finest lush grass on this side of our lovely isle of saints and scholars... nope, the cows are still chewing, Danny, you're all right.

DANNY: Shut up will you, I'm trying to psyche myself, why do you have to do that anyway? It makes them stare, it makes me nervous.

JOE: You should soak it up Danny, who else will be looking at you?

DANNY: You know you make silence sound just wonderful, Joe.

JOE: It's not my fault you're built like a scrawny little ferret... we could call you ferret head...

(*Laughs.*)

Ferret head...or maybe rat...rat head...

(*Laughs again.*)

DANNY: Yeah well at least I don't make the earth shake when I go for a stroll.

JOE: (*Looks down at himself, then back at her.*) It's muscle.

DANNY: (*To DES.*) Last time he dove into the pool there was almost a tidal wave.

JOE: It's all muscle I said.

DANNY: Course it is Joe, all those Mars bars are low in calories and high in muscles, sure we all know that.

JOE: I'm going to do you a favour and break that mouth of yours one of these days.

DANNY: Just try and catch me tubby.

JOE: Keep going that way and you'll find out...did you hear that Des? The cows are making her nervous...you're a feckin lunatic, Daniella, do you know that?

DANNY: I'm not the one talking to the cows and it's Danny, how would you like if I called you, Joeseph?

JOE: How would you like my boot in your skull?

DANNY: Des!

DES: Right so, who is up first?

JOE: I'll go.

DANNY: To prove your point...

JOE: Well, I am the man.

DES: Then Danny –

JOE: Shaking and quaking, afraid of her life.

DANNY: (*Unconvinced and shivering.*) This is great this is, I love this I do.

DES: Then me.

(*Pause, deep breath, light and sound FX, water rippling light effect, mood music.*)

In the quiet time,

Standing there on the edge,

With a forty-foot drop below you and the cliff edge all
rough like a scarred face.

JOE: Just standing there –

DES: Breeze like a flat palm against your forehead –

DANNY: Or a gale pushing your shoulders back –

JOE: Trying to reason with you like a parent or something
and then feet leaving the wet sea grass as you step out into
nothing.

(*Echoed by other two, voices enhanced to echo longer, sound FX.*)

DES: Nothing.

DANNY: Nothing.

JOE: Sliding through.

DANNY: Falling through.

DES: Flying through the air and the cliff side tears past you
like the pages of a book you're thumbing through too
quickly.

JOE: That's the rush, the flying, the blood surge.

DANNY: No it's the fear of the fall.

DES: No it's to touch the water, to have the water touch me.

JOE: And it flies up in a wall to meet you in an instant.

DANNY: And you're through.

DES: And you're going way down into the blue like lead.
(*Pause.*)
Once you're down though…heaven.
(*JOE breaks the spell first, looks over at the other two
who are still lost in thought. He breaks free once more and
jumps to level one to the audience. Agitated again, almost
desperate.*)

JOE: That second, that moment, that madness…that's the best
part of it, the best part of all of it, everything… everything
switches from black and white to colour just for a second,
just for a split second, just long enough to show you what
you're missing out on for the rest of the day.
(*Lights even out into daylight again.*)
At least it's Friday though right lads?
Bit of drinking, bit of dancing, bit of…close your ears,
Danny.

DANNY: What makes you think that I was listening?

JOE: I'm off, see you outside Brandon's at nine, don't be late!

DES: We going with Kieran?

JOE: Am...no, Kieran's car is full, Jason Green is giving us a lift.

DES: The guy with the twitch?

JOE: Yeah.

DES: Never liked him.

JOE: Yeah well, it's that or walk, your choice Des. I'll see ye at nine.

(*Leaves.*)

DES: Jason Green.

DANNY: What does it matter? He's just giving us a lift.

DES: I guess.

(*Long pause as DANNY tries to work her way up to asking DES something, but when she finally does he cuts her off.*)

DANNY: Des I –

DES: I wish I could study like you, Danny, it's all like Chinese to me, and I'm so crap at maths, Mr Murphy thinks I'm being thick on purpose but I just don't get it that integration stuff, it just won't stay in my head.

DANNY: It's not like it comes easy to me either, Des, I have to work at it you know. Listen I –

DES: Yeah but I can't concentrate on it, and there's always so much to do at home.

(*Pause.*)

I dunno what I'm gonna do about the exams.

DANNY: (*Gives up.*) Well, you know, there's plenty of time yet, I suppose, it'll be okay, I'll give you a hand with the maths if you want I better go, I'll see you later yeah?

(*Stops.*)

Des?

DES: Yeah.

DANNY: Did you tell Joe yet? About us and Greece and everything?

DES: Not yet, I will.

DANNY: When Des? Look it's only a few weeks now and –

DES: I said I will Danny.

DANNY: (*Hurt.*) Okay. See you later.

DES: Nine o'clock.

DANNY: Nine o'clock.

Scene 6

JOE has been seated in shadows on level one, now jumps into action as lights spring up. DANNY and DES make their way down quickly.

JOE: Nine o'clock, come on come on, we're losing drinking minutes.

DANNY: Keep your shirt on it's only five past.

JOE: (*Looks at her and then turns to DES.*) Look does she really have to come? I don't think she's house trained and I wouldn't want her making a mess of Jason's van. Seriously you know, she's only cramping our style, it's not easy to score if there's a ferret hanging off your arm.

DES: She wouldn't hang off your arm if she was paid to.

JOE: What's that supposed to mean?

(*Pause.*)

I'll have you know I have no problem with the ladies.

DANNY: It's true, he doesn't, Des.

JOE: Thank you, Danny.

DANNY: It's the ladies that have the problem with him.

JOE: Leave the books at home did you Danny or are they in the bag?

(*She sticks out her tongue at him.*)

See what I mean, Des? She can't even be civil…

(*Three sit suddenly side by side on ground in a box of light, the only light on stage. Sound of van changing gears.*)

JOE: Heading up in the back of Jason Green's van. Have we brought the supplies?

DES: Armed to the teeth.

JOE: Cider.

DANNY: Check.

JOE: Fake IDs.

DES: Check.

JOE: Got your johnnies, Danny, just in case.

DANNY: Fuck off, Joe.

JOE: (*To DES.*) He's not a bad sort, you're too hard on him.

DANNY: Give the bottle Joe, give it, will you.

DES: I just don't trust him, and I don't think you should either.

JOE: Keep it down will you, he's not exactly ten miles away.

DANNY: Give it, Joe. Des?

DES: He'd rob his own mother if he had half the chance.

JOE: No he wouldn't, that's a terrible thing to say,
 (*Pause, seriously.*) that's how rumours get spread you know.

DANNY: I said give it, Joe.

JOE: I only got it this second. Look, any chance of a loan,
 I know I borrowed off you last time but I'll have it by
 Monday I swear…I dunno what's wrong with me these
 days I'm drinking like a fish.

DANNY: Yeah you are, give the bottle here.

JOE: I said I've only had it five seconds.

DANNY: Liar, you have it since we passed through Kilnaboy.

JOE: I have not, so is that all right? I'll give it back Monday,
 Des, I swear.

DES: All right so.

JOE: Thanks Des, sound.

DANNY: Des, make him give me the bottle, he's had it since
 Kilnaboy.

DES: I dunno should you be drinking so much with your fits
 and all and –

DANNY: Ah Des.

DES: I'm serious Danny, what if one of these days you have
 one and we're too drunk to help you?

DANNY: Des.
 (*Louder.*)
 Des.

JOE: He's right Danny, you should be taking it easy.

DANNY: Shut up or I'll –

JOE: You'll what Danny, you'll what?

DES: I'm trying to figure if you two get louder by the flagon
 or by the mile.

DANNY: Des.

DES: What?

JOE: Make her shut up.

DANNY: Make him give it to me.

DANNY: Tell him, Des.
 (*Music and lighting change, the three stand out of the light and
 into the city, the three face the audience, JOE steps forward.*)

JOE: Stepping out into the city and it is the most beautiful in

the world.

DANNY: Cider flavoured.

Heading up towards the disco, trying to look older and more sophisticated.

DES: Like the college students we're surrounded by, and it's all going to plan and –

JOE: (*Stepping back beside DES and two look off to stage left.*) Would you look at the state of your one.

DANNY: (*Walking forward and becoming the character she is describing.*) Dolled up to the nines, white blond hair in a pile on her head, blood red lips, pink snakeskin mini skirt, white PVC jacket, eight inch high heel, a little bit very drunk.

(*JOE and DES step forward as bouncers, each with a hand on her shoulder.*)

JOE: ID there miss if you don't mind.

DES: A little merry are we?

JOE: A little twisted maybe?

DANNY: I usually have it but my wallet got nicked on the bus on the way in and I –

JOE: What's your D.O.B?

DANNY: My what?

DES: Your D.O.B.

JOE: Your date of birth.

DANNY: (*Obviously mentally counting.*) Eighty-three…no. Eighty-two…no.

DES: Student are you?

JOE: Maths is it?

DANNY: What?

(*DES and JOE look at each other and then back at her.*)

DES/JOE: You're not getting in. Not tonight. Next.

(*Both turn their backs to her.*)

DANNY: But I, my flatmate is inside and she has my keys.

(*DES and JOE shake their heads.*)

My boyfriend is waiting for me in there, he's my only way home.

(*DES and JOE shake their heads.*)

But I'm in here every night of the week.

DES: (*Turning.*) What did we just say?

DANNY: But my flatmate –

JOE: (*Turning.*) You're not getting in!

DANNY: My boyfriend.

DES: Do you speak English at all?

JOE: Stand away from the door you're only making it harder for yourself.

DANNY: But –

DES: What did he say?

JOE: What did I just say?

DES: Next.

DANNY: (*As herself.*) She turns from the door, with tears making little river lines through her make up.

JOE: Next.

DANNY: Her manky hair falling down around her face and then it starts to rain as she walks away with her little pink bag trailing after her like a tail between her legs…how can she walk in those shoes?

JOE/DES: (*Stepping forward.*) Next.
 (*DANNY looks at them startled.*)

DES: ID's there boys if you please.

JOE: What's wrong with ye.

DES: Do ye speak English at all.

JOE: IDs.

DES: Up from the country are you?

DANNY: I'm a computer science student.

JOE: Yeah and I'm Elvis Presley.

DES: And I'm fucking Ricky Martin.

JOE: What's your point?

DES: What's the story?

JOE: Where's your ID?
 (*DANNY produces ID and stands waiting.*)

DES: Right so.

JOE: In you go.
 (*Lighting and sound change, loud pulsing music, they have to shout to be heard.*)

DES: Inside the club

DANNY: My heart is swimming

JOE: The music is pulsing strong dance

DES: Tribal dance

DANNY: There are sweaty pretty people everywhere

JOE: Up to the bar

DANNY: Stand at the bar

DES: Stay at the bar for an hour and a half... (*Drunk.*) Stout from plastic glasses settles like butter in my stomach.

DANNY: (*Very drunk.*) I can see two of everything, (*Giggles.*) like on the ark, get it? The ark?

(DES and DANNY step stage right with their backs to JOE who steps into a light stage centre.)

JOE: I break off into the back room, (*Harder dance music.*)
Talking to Jason about taking something
not the robbing kind of taking,
the ingesting kind of taking
just about to do the job when –

DANNY: (*Drunk.*) What's that you have there?

JOE: The ferret. (*Hand behind back.*) Nothing Danny go 'way will you.

DANNY: Show me show me.

JOE: Fuck off will you Danny, where's Des?

DANNY: (*Messing with him, trying to open his hand.*) Show me you big baby, what have you.

JOE: Danny your nails, oww...
(Drops what he is holding, shouting.)
– will you fuck off Danny? Look what you did –
(Music fades down, DANNY turns and stands with back to him and freezes.)
On the ground on my knees, fumbling through the shoes and the laces and people quenching cigarette buts on the back of my shirt, ah for fuck's sake, Danny, for fuck's sake, high heels on the back of my hands
(Pulls his hand to him rubbing it.)
and it's all dark and grimy and broken glass and then I see them, lying together at the feet of some girl, just lying there like two perfect little moons in the dusky dirty carpet
(Mimes picking them up and looks at them in his hands.) just perfect.
(Music up.)

DANNY: I'm sorry, Joe, what are you (*Sees them.*) oh...am...
(Doesn't know what to say or do.) am...

(*Music cuts.*)

JOE: Out of the club and on to the street – (*Sound and light change to street scene.*)

If you tell Des I'll break your face for you I swear it Danny I swear it, do you hear me.

(*DANNY is drunken and dazed.*)

Look they're not even mine they're Jason's, Danny.

(*No answer, grabs her by the shoulders.*)

Danny, not a word all right, not a word.

(*DANNY shakes her head.*)

JOE: Promise?

DANNY: I promise.

JOE: Come on then, he'll be looking for us.

DANNY: Joe.

JOE: Look Danny don't give me grief.

DANNY: I won't, I'm not, I just, what's it like?

JOE: Ah Danny.

DANNY: Seriously, I'd like to know…

JOE: It's…it's…I can't describe it Danny.

DANNY: Try, ah please Joe.

JOE: Look you wouldn't understand.

DANNY: Explain it then.

JOE: (*Sits beside her.*) It's kind of like…well you know the way…

(*Switch back to DES in the club.*)

DES: My stomach is twisting from drink,

Everyone is swimming about,

And there are so many pretty girls…

I'm drunk

I'm on the dance floor,

with everyone,

eyes closed,

all moving together.

(*Switch back.*)

DANNY: So you're just happier?

JOE: Yeah exactly, happier.

DANNY: Why?

JOE: What d'you mean why?

DANNY: Well why are you happier what makes you feel happier?

JOE: Well you just do, you don't know why, it's sort of like –

DANNY: Like drink? The way you feel better?

JOE: Yeah…well…no, it's like, like you're really optimistic about…about everything, and you think everyone is fantastic and you want to be everyone's friend and to know everyone…everyone seems really nice and…and the music…

DANNY: The music?

JOE: Yeah it's like someone told you a whole new way of listening to it so you're not actually just hearing it you can almost feel it or –

DANNY: How?

JOE: (*Big sigh.*) Well it's almost like –
(*Switch back into the club.*)

DES: A pretty girl with a brown-eyed smile
takes hold of my hand,
She's a college student,
Sports medicine, in her third year
I'm ashamed to tell her I'm only in school
afraid she'll let go of my hand.
(*Switch back outside.*)

JOE: Well there isn't any really.

DANNY: There has to be.

JOE: Well, you feel kind of shitty the next day, but that's it really.

DANNY: What about people dying from them and stuff.

JOE: That hardly ever happens Danny, they're just trying to scare people, once you get them off people you know you're all right.

DANNY: What about the people they get them off?
(*Switch to DES.*)

DES: I tell her I'm a student too,
She's impressed,
I'm afraid she'll stop this sweet heat that's spreading all over,
So I tell her I'm doing law,

She lifts her face to mine and pushes her tongue through, I
close my eyes and wonder if this is what beauty tastes like.

JOE: And it's a great night.

DES: A great night.

(*Music cuts.*)

DANNY: (*Sadly.*) Yeah, a great night.

(*FX change, back in Jason's van.*)

JOE: Up the front of Jason's van, listening to the tunes.

DES: Down the back,

Danny's awful quiet,

I said you're awful quiet Danny,

You cold Danny? You want my jacket?

DANNY: No. (*Shivering.*)

DES: What's wrong with you? You pissed off with me?

DANNY: (*Pause.*) Do you ever…do you ever wish it was the
way it was before?

DES: When before?

DANNY: Before… (*Gestures about her.*) before this…

DES: Before Jason's van at four in the morning?

DANNY: Before…before clubs and drink and…and
everything…

DES: I don't remember it being much different…

Scene 7

*Three stand and hold for a second, lighting dim and change,
playground noises filter through, lighting up suddenly and the three
snap into action, very young. DANNY is upset and talking to DES.*

DANNY: Yeah but it's my football.

DES: You'll get it back tomorrow.

DANNY: Yeah but my Dad only gave it to me this morning,
Des.

DES: You won't get it at all if you show him you're pissed off,
you know how he is.

(*DANNY starts to cry.*)

Danny I'm telling you.

JOE: Well look at baby Daniella, did you lose something
Danielle or did you wet yourself and you want your dolly?

DANNY: It's Danny, and I want my ball back Joe, my Dad
gave it to me.

DES: Just give it to her.

JOE: Look at you standing up for your girlfriend, Des and
Danny sitting up a tree, K-I-S-S-I-N-G...
(*DANNY starts to cry again.*)

DES: Can't you leave her alone?

JOE: Shut up you Des Foley.

DES: Just leave her alone.

JOE: (*Flexes his muscles, tries to look threatening.*) Des Foley...I
could thump you so hard...that –
(*Thinks.*)

DES: Yeah?

JOE: So hard that it would...
(*Thinking really hard.*)

DES: Yeah?

JOE: (*Frustrated. Shouting.*) That it'd...it'd...it'd make your
brain flat as a pancake Des Foley, if I wanted to...
(*DES laughs.*)
What whAT WHAT? What are you laughing at? You think
I couldn't do it? I could I could flatten you.
(*DES and DANNY laugh more.*)
What are you laughing at?

DANNY: Nothing...only you wouldn't have to hit him to
flatten him, Joe.

JOE: What d'ya mean?

DANNY: Well you could just sit on him.
(*DES and DANNY laugh and JOE goes for DANNY.*)

DES: Come on Joe, give her back the ball, look your Da is
coming...

DANNY: Your Daddy is a pervert Joe, my Ma says it and
everyone knows it.

JOE: What would your Ma know? Isn't she daft as a brush.

DANNY: Shut your face Joe Leary.

JOE: I'll shut yours for you first.

DES: Stop it will ye.

DANNY: It's not true Des it's not.

JOE: It is too true Des, the whole place knows it, everybody

knows it, ask anybody, ask everybody.

DES: Just leave it, both of ye?

JOE: (*Pause.*) What does she want with a football anyway, she's only a girl...

DES: You all right?

DANNY: It's not true Des, it's not.

DES: I know that, sure I know that, come on so Danny, we'll go up the cliffs will we, come on we'll jump from Hamilton's gate before dinner...?

DANNY: All right so...

JOE: Can't I come?

DES: Will you bring Danny's ball in tomorrow? Will you?

JOE: Okay okay...

Scene 8

DANNY as Mr Leary, on higher level to the boys, DES is trying to listen, JOE is bored.

DANNY: (*As Mr Leary.*) Well then, as I was saying it's all about concentration, imagine yourself as a knife boys and cut through the water cleanly and evenly, no point being there and not there, must be two-hundred percent in the water, I remember back in the 1976 Olympics when I –

JOE: Christ he's off again, 'When I was at the Olympics in '76...', it will be carved on his feckin tombstone.

DES: Sshhhh...that's if they can shut him up long enough to bury him.

(*Boys laugh.*)

DANNY: (*As Mr Leary.*) Again Mr Foley and Mr Leary are amused, do tell us what is funny enough to stop me twice in five minutes...well Mr Leary? Something funny about concentration? perhaps some grain of wit I could include in my little speech?

JOE: (*Pained and slightly scared.*) No sir.

DANNY: (*As Mr Leary.*) Speak up, champions don't mumble.

JOE: I said no sir.

DANNY: (*As Mr Leary.*) So you were laughing at nothing is that correct, Mr Leary?

JOE: No sir...yes sir...well...we were...I mean...

DANNY: (*As Mr Leary.*) Idiots laugh at nothing Mr Leary, so if you were laughing at nothing what can we deduce from that? Hhhmmmmmm?

JOE: I dunno sir.

DANNY: (*As Mr Leary.*) Case proven, let me help you with it Mr Leary, you are in fact an idiot Joe Leary, and idiots never succeed so can we therefore deduce that you are a failure, are you following so far...well, Mr Leary...? Hmmm... I'll see twenty laps while you're thinking about it. They say exercise stimulates the brain let's push it to the limits with your pathetic skull shall we?

DES: I should do them too.

DANNY: (*As Mr Leary.*) Sorry, Mr Foley?

DES: I said I should do them too, I was laughing too sir, I should do the laps too?

DANNY: (*As Mr Leary.*) Are you an idiot Mr Foley?

DES: No sir.

DANNY: (*As Mr Leary.*) Then shut up and continue with your warm ups, the heats are less than a week away and seeing as you are no idiot then we can assume you have a shot at a medal. Understood?

DES: Yes sir.

DANNY: (*As Mr Leary.*) What the hell kind of stroke do you call that Mr Leary? Some sort of mutated doggy paddle? Lift your arms boy, lift, you're thrashing about like a mad thing, how can you...

Scene 9

Darkness. DANNY jumps to level one and stays on her hands and knees. Lights up on JOE and DES making their way up to level three. JOE is overly excited by what he is saying, trying to address it just to DES, DANNY keeps interrupting.

JOE: They were all over the strand sure you must have seen them.

DANNY: Wait will ye, give us a hand.

DES: I'm telling you I didn't.

JOE: But they were all over the strand, there was at least

twenty of them.

DANNY: Lads.

DES: When was this?

JOE: This morning before school, did you not see all the squad cars? There was five or six of them.

DES: I came in late, had to help my Da this morning.

DANNY: Lads, lads.

JOE: What whAT WHAT!

DANNY: What?

JOE: You're yelling like a baby what's wrong with you?

DES: What's the matter Danny?

DANNY: (*Embarrassed.*) I fell.

JOE: Oh for fuck's sake.

DANNY: I hurt my knee.

DES: Just try –

JOE: Just come on will you, so anyway, it was a German or a Swedish ship and Mike Douglas said his Da was working when they brought them in, but they couldn't charge them cos' they had thrown the stuff overboard and –

DANNY: What stuff?

JOE: And they found some of it up the coast but they reckon there was more so they –

DANNY: What? What stuff Des? Des?

DES: Drugs, Danny.

JOE: (*Looks nervously about him.*) Ssshhh… Des will you –

DES: What's wrong with you? You think the cows are listening?

DANNY: (*Shocked.*) Drugs…really? Where?

JOE: Would ye shhh…what did you think we were talking about for the past twenty minutes?

DANNY: I dunno…some film or something.

JOE: A film…she's just such a – look could we just hang out without her for a while?

(*To DANNY.*)

Would you go home…

(*She ignores him.*)

Look at her she's like a stray cat or something.

DES: Here can we do the not studying thing at your place tonight? My Da has a load of the GAA crowd coming over

after the meeting.

JOE: (*Mocking.*) Patsy Cronin, Fiachra and the boys?

DES: Yeah.

JOE: The loud and the proud.

DES: Anyway, can we do it over at your place?

JOE: Didn't I tell ye? I can't make it tonight.

(*The other two look at him in shock, they always study together.*)

DES: How come?

JOE: I'm going to a party down the coast with Jason, you can come if you want Des, but not her.

DANNY: – as if I'd want to.

DES: But it's a school night.

JOE: You sound like my Da, 'but it's a school night', some of us have better things to be doing than making sandwiches for GAA anonymous?

DES: Oh shut up.

JOE: Why you always telling me to shut up?

DES: Why are you always saying the wrong things?

DANNY: (*Trying to diffuse the tension.*) I met your Da down the post office, he was looking for you.

DES: Isn't he always.

DANNY: And Joe's Da says you're a sure thing for the freestyle and the crawl on Friday.

DES: (*Glaring at JOE.*) If I don't get kicked off first.

DANNY: What do you mean?

DES: Ask Mr Leary here.

DANNY: (*Confused.*) You hoping for a place?

JOE: I mightn't bother with it you know…couple of the lads robbed a keg from the back of Sullivan's, they're tearing into it that afternoon so you know…

(*Peace offering to DES.*)

…you can come along if you want.

DES: If I don't get a medal I've no chance at that scholarship.

JOE: To Berkley?

DES: Yeah.

JOE: Would your Da not pay?

DES: (*Stands and walks forward, his back to JOE, doesn't want him to se his face.*) My Da wants me to be a quantity surveyor.

JOE: What's a quantity surveyor do?

DES: I don't know really.

Dowling told him that there is big money there. Failing that, working with him on the farm I guess.

JOE: What stay here?

DES: Yeah…it's not so bad.

JOE: Are you off your game altogether?

DES: What's so bad about it?

JOE: Nothing…except everything…staying here, working on the farm…

(*Laughs.*)

After what we said about it being like fecking clockwork, same every day, bloody terrible.

DES: You said that.

JOE: How could you want that?

DES: What about you?

Exams are next week,

What are you going to do?

JOE: Dunno, don't care.

Get out of here like a bullet from a gun I'll tell you that much.

DES: What does your Da have to say about that?

JOE: What's it got to do with him?

DES: Nothing but…

JOE: It's none of his business it's got nothing to do with him.

(*Awkward silence.*)

DANNY: I gotta go, (*To DES.*) you'll be all right?

DES: Course I will.

(*Exit DANNY to Level Two.*)

JOE: It's getting dark, you want to go first?

DES: Nah you go on…watch out for the current, I think the tide is turning.

(*JOE doesn't move.*)

Something wrong Joe?

JOE: No, why? Why what have you heard?

DES: Nothing, why what should I have heard?

JOE: Nothing.

DES: Right so…off you go then.

JOE: Yeah… (*Stands, takes a few steps. Pause.*) I'll see you later then.

DES: You will Joe.

JOE: Right so...actually I might have a smoke after all.

DES: Hang on to this one, I'll be back in a second, nature
calls.

(*Takes the cigarette off DES, watches him go, nervous, pulls
heavily off the cigarette. Agitated. Trying to psyche himself
up to telling DES something.*)

JOE: Des listen I...

Hey Des I was thinking maybe...

Des, am, you know what about...do you want to maybe
come into the city with me tomorrow night? With me, you
know, boys' night out, the lads...

(*Shakes his head, takes another drag. JOE tries again.*)

Here Des, what about going on into the city tomorrow
night? You know? Maybe...

(*Flustered.*)

Maybe we could catch a movie have a few pints you know,
you and me, the boys you know, the lads...

(*Stops again.*)

Oh Christ.

(*He turns back to DES and we hear him.*)

(*JOE turns back and takes another drag. Then, down on his
haunches putting it out.*)

Des... The thing is Des, what I was saying about the cops
and the strand,

What I was saying just now, when Danny wouldn't shut up
and I was trying to,

Christ,

it's not stealing because it's from bad people and that
doesn't count...and they won't be looking for it, it's not
stealing, Jason said he just found it you know, just lying
there under the boat shed,

and now Jason,

and Jason he's all right you know he's...he's all right,
he knows about...stuff,

he has this friend in the city who knows about things like
that and he says if I help out I'd get a cut, he says we can
go tomorrow night and if you come...if you come I'll give
you half no problem, no problem

(*Enter DES.*)

DES: Who were you talking to Joe?

JOE: No one, I wasn't talking I was…no one…

DES: Christ who's touchy…first sign of madness you know.

JOE: …look, Des…

(*Re-enter DANNY.*)

DANNY: Hey Des, hey Joe.

DES: I thought you were going home…

DANNY: I am…well I was but, it's too dark…can I come to your place for dinner.

DES: Course you can and –

JOE: (*Ignoring her.*) Des you want to come into the city with me tomorrow night?

DES: What?

JOE: You know (*Swallows hard.*) like into town, a night on the town like.

DES: I dunno Joe, my Da –

JOE: Forget your Da aren't I promising you sweeter things?
Come on,
Last time I was up on a Thursday I met some college girls that would screw you as soon as look at you,
Come on Des come on,
what have you got to lose?

DANNY: The heats are Friday, Des.

JOE: Danny stay out of this, Des we'll be back well in time, have a few beers, pick up some college woman and be home for three, the heats aren't until four o'clock Friday, Des.

DES: I've no money either and I'm not asking my Da.

JOE: (*Getting desperate.*) I'll pay for it, you know a lads' night out yeah?

DANNY: But the heats –

JOE: I said stay out of it.

DES: (*Cuts him off.*) – look I'm sorry but I don't think so, but thanks Joe, thanks for asking…anyway, Danny what do you think of the –

JOE: Des come on I'll give you the money no problem, no problem.

DES: I can't, I wouldn't be able to pay you back or anything,

JOE: Please Des.

DES: I can't, we'll go Friday night yeah, and I'll have money then and –

JOE: No we have to go tomorrow.

DES: Why?

JOE: Because we just...look, please Des?

DES: I don't see why it has to be tomorrow.

DANNY: Yeah Joe what's the story?

JOE: It's got nothing to do with you, look Des –

DANNY: (*Offended.*) I was just asking you know...

DES: Yeah Joe, calm down will you, we'll go Friday.

JOE: (*Very distressed.*) What are you afraid of?

DES: What are you talking about, what have I to be afraid of?

JOE: You're just always the same, any chance to get out of this place and you're hanging on like –

DES: Don't start Joe.

DANNY: What...what's going on?

JOE: Des is just being a big girly,

just like yourself, sure that's why the two of you are as thick as thieves anyway aren't ye?

Both as weird as each other...

I tell you your mother and your father should get together and –

DES: I'm going.

JOE: That's right, run away you girl you.

DANNY: Des...why don't you leave him alone?

JOE: (*Angry and lashing out.*) Look at you standing up for him, wake up,

he doesn't even like you, you fool,

he laughs at you behind your back,

he thinks you're a freak...

DANNY: Shut your face, Joe, that's not true, you know it's not...

JOE: And you...you little fucking snitch...

(*Grabbing her.*)

I bet you told him didn't you...didn't you?

DANNY: I didn't I swear I –

(He releases her and she exits.)

JOE: That's right, run away you baby...
(Thinks about it and shouts after her.)
Oh Danny...Danny come back...what are you doing tomorrow night, Danny? Danny?

End of Act One.

ACT TWO

Scene 1

The three are on level one, speaking in turn to the audience.

DES: Thursday,
 It was just
 one of those mornings,
 you wake
 and before you even open your eyes
 you can feel the warmth in the room,
 and when you pull the curtains back,
 the heat floods onto your face
 and outside –
DANNY: There's a touch of magic about everything,
 like it's all been dipped in crystal over night
 and the day seems like it's
 calling you out there to play,
 and you dress faster than usual and
 wolf down your cornflakes just so you can
 be out there, part of it and –
JOE: Stepping outside,
 you can't believe someone has swapped the
 gales and wind of the west coast
 for this,
 and you can't imagine how
 anything bad could ever
 happen on such an –
DES: Absolutely.
DANNY: Spectacular.
JOE: Stunning.
DANNY/JOE/DES: (*Together.*) School day.
 (*Switch to JOE's house that morning, then alternate to each, the
 three play to the audience, and build it up.*)
JOE: Oh Ma, I don't feel so good, my belly, it doesn't feel
 so great, I think it was that fish we had last night, I didn't
 sleep so well and –

DES: I think I feel a weakness coming on, my legs, they feel
a bit like jelly so they do, like they could give way at any
time, and my arms too, it's an effort to move Da –
DANNY: My head, it's not the best to talk the truth, I feel a
banging on the inside of my skull, a great banging like a
big man with a drum in my head, Mam, and an awful heat
and –
JOE: Do you not think –
DES: That it might be best if –
DANNY: For the sake of my health and all –
JOE: That I –
DES: Should maybe –
DANNY: Stay home?
> (*Hold for a second, then respond as if are after being told
> there is no earthly way they are being allowed to stay at
> home, then JOE and DANNY turn in disappointment and
> stand stage right while DES walks into centre spotlight.*)
DES: Outside the day is so beautiful I want to cry,
the road is hot already,
sticking tar to the soles of my shoes,
I turn out from our gate and see her there before me,
all shimmering and shining in her milky blues and greens,
We have grey summers here,
but not today, look at it,
they won't do a tap in the school
last day today and they'll only be giving awards for the
best footballer and the best hurler,
the exams though,
I get a burning in my chest when I think about them,
but it's the last day though,
and the heats are tomorrow.
JOE: I'm walking fairly slowly,
I'm afraid I'll meet my Da on the way in the school gates,
he gets up at six to train,
and he'll go mad if he sees me only just arriving,
when I was supposed to have thirty laps done before
school.
Last time he hit me in front of all the lads
and they laughed and Derek Mulvey said I was

my mother's daughter and I should be in the Colaiste with
his sister Brid,
(*Pause.*)
he won't say it again.
I hang back and light up a cigarette
drag my feet, go the long route,
check the boat shed where I've left the bag,
think about how this is the beginning of everything else,
of everything good.
What a day,
I tell you,
what a day.
DANNY: I'm not sure if it's the heat or what
but the walk down is a nightmare,
my head feels full of sand,
it's such a beautiful day.
They've been saying more things,
bad things,
about me in class these days.
I always put my head down and let it wash over me,
and at lunch,
I stay in and I read sometimes...
Down the main road towards the school and there are two
of them behind me,
I hear them before I see them...Debbie Wilson...
Her Dad is the Bank Manager,
(*Turns.*)
fuck off will ye...
Debbie Wilson...I'll break your face for you...
They're saying things, about
(*Looks down at her clothes and touches her face.*)
I said fuck off...
And then the unthinkable,
I trip, foot just gets caught and I hit the roadside face
down...
They're laughing...
sounds like there's fifty of them,
laughing, above me.
So I stay down.

Face down,
stay down...
DES: I go straight for the pool,
I can see the lads are all only down the strand anyway.
Playing soccer,
I want to train,
I strip to my shorts and there's no one there but me.
The water's like a sheet,
I dive through and start to stroke.
Find the rhythm.
Two hundred percent in the water, two hundred percent
concentration.
Cut through the water like a knife.
Feel my body change gears like an engine and this is it,
I feel it.
This is the first day of something else.
JOE: I see my Da talking to Mrs Combers outside the main
door,
I wait for them to go in,
and make for the door,
I think I'll tell him I was training down the strand or –'Oh
good morning Da, didn't see you there'
I try flick the cigarette away and go on
'the pool was a bit jammed so I eh...I went down the
strand,
I did, I swear to Christ I'm exhausted I tell you I, what
cigarette?
No Da,
I was just holding for someone else,
no lies, I wouldn't –
(*Is hit.*)
I swear I –
(*Hit again.*)
I...I...I'm sorry.'
DANNY: I lean against the wall for a while
and then I turn for home,
but they're still behind me,
they're throwing gravel at the back of my legs.
My head is still swimming.
Try to get away, have to get away

(*More laughter.*)
Debbie Wilson...I swear I...
(*Breaks.*)
I...please...
please...
I don't feel so good
(*More laughter.*)
and my head is spinning and I'm screaming at them.
Something flips into place and I'm
tearing down towards the strand,
have to find the lads,
Joe Leary will sort you out you fat cow,
Or Des...
Des...

DES: I'm well into it now,
must be on my twentieth lap or so,
when I see him standing at the side of the pool,
my lungs freeze,
he doesn't look happy.
I swim to the side and
'good morning sir,
No sir,
what?
Special, sir, no I don't think I'm special it's just with the
heats tomorrow I –
But I don't play soccer I –
And with three words he shatters everything that was
perfect about today,
Off the team
But I'm team captain sir –
It's tomorrow sir,
the medal, the scholarship,
You can't do that sir,
You – '

JOE: And this of course has to happen right outside the sixth
class window,
and the first thing that I see is his back walking away from
me
I think I hate that back more than anything else in the

world.
Second thing I see
is Derek Mulvey looking right at me,
grinning,
I wipe the blood from my face and
I can handle one more day with Da,
but Mulvey,
I swear he'll get it today I swear that's it,
if he says it once more,
'if you don't shut up Derek Mulvey I swear you'll have my
boot in your skull'
in the playground,
the heat is intense,
there's sweat running into the cut on my forehead,
and it stings,
Derek and the boys are pissed off because the footballs
are below on the strand with the fifth years,
and they've nothing to do except –
'shut up Mulvey, or I swear it,
what are you looking at Denis Chambers?
are you looking at me?'
And part of me knows it's not worth it,
but
something small is just threatening to snap,
if he says it once more and part of me wants him to say it
once more,
'say it once more Mulvey, I dare you once more'
(*Pause.*)
then he does
and I have him on the ground in less than a second,
shut up shut up shut up.
DANNY: They're all on the strand,
the lads are playing football or skimming stones but
I'm looking for the lads,
can't see Des.
Mrs Combers comes over and wants to know why won't I
play with the rest of them,
I try and explain,

there's a roaring in my ears and I can't hear myself talk,
(*Lighting change to isolate her, she physically reacts as if a needle has been stuck between her eyes, in obvious pain for the rest of this speech, it is slow and drugged.*)
am I talking at all?
She's looming over me,
she's like a great beached whale, I think,
and then I tell her,
you're like a great-beached whale Mrs Combers, did you know that?
But the banging gets louder and louder,
and my leg starts to shake,
I'm looking at it,
(*Falls to her knees, rocking forward and back.*)
but I can't stop it,
and then the other one starts,
Mrs Combers face is getting redder and redder,
looks like it's going to explode,
I try to tell her but
(*Lights cut to a single strobe, she moves in the light for a moment, rocking back onto her heels and then coming up to kneel facing the audience, calmer now.*)
it's like someone reaches in to my head and changes the frequency, with a warm liquid hand, and all I can feel is a sweet heat spreading up from my tummy, and
a smile to match on my face, and then everything is perfect, and it all goes dark.
(*Switch to the boys on second level.*)
DES: But you can't do that.
JOE: Someone pulls me off Mulvey.
DES: But the heats are tomorrow you can't.
JOE: He's not talking can't see if he's breathing.
DES: And I just run away.
JOE: Just run running out of the playground.
DES: Way down along the strand.
JOE: Up towards the point,
 can't feel my hands...

DES: Can't think evenly –
JOE: Like they're not even there.
DES: Can't breathe evenly.
JOE: Christ.
DES: Christ.
JOE: When he finds me.
DES: He'll tell my Da.
JOE: When he hears that I –
DES: For sure he will and Christ –
JOE: Christ.
DES: He'll kill –
JOE: He'll kill me.
 (*Back to DANNY, FX as before.*)
DANNY: I'm coming around,
 feet all about my face,
 sand and blood in my mouth.
 Staring.
 Pointing.
 Wish I could move…
 (*DES arrives at cliff where JOE already is, holding his hand to his face.*)
DES: What happened you?
JOE: Fight.
DES: Where?
JOE: Yard…
DES: Does it hurt?
JOE: Nah not much…you should see the other guy.
DES: Who was he?
JOE: Who was who?
DES: The other guy.
JOE: Nobody.
DES: Nobody who?
JOE: Derek Mulvey.
DES: Mulvey, he's half the size of you.
JOE: What does it matter anyway, where were you all
 morning, my Da was looking for you?
DES: He found me.
JOE: (*Laughs.*) How many laps he make you do?
DES: None.
JOE: You're joking, you're such a fluke, he almost killed me

this morning.

DES: He kicked me off the team.

JOE: But he can't.

DES: He says he can.

JOE: But the heats, Des.

DES: I know.

JOE: What are you going to do?

DES: Study I guess, nothing else I can do.

JOE: Look I'm sorry about the other night, Des.

DES: I don't care.

JOE: No I am

I'm sorry about what I said to Danny, and what I said
about your Da,

I'm sorry,

it's my ould lad,

he gets to me.

DES: That isn't it.

JOE: Won't you come with me tonight?

DES: I've already told you I can't and I won't.

JOE: Look…but you're not even in for the heats tomorrow.

Look you have to come, it's real important that you come.

Look I said you would.

DES: Said to who?

JOE: To Jason…

There has to be two of us and I told him you'd come…

DES: What are you talking about?

JOE: Look, just listen for a second?

(*Back to DANNY.*)

DANNY: I wake to see that I am fenced in,

shoed in.

Surrounded by the staring and the pointing and the
laughing,

I try to move,

then not to,

I see rain break over the shoulders of my audience and
pray for the weather to shake them.

JOE: Jason has it all fixed up.

DES: (*Listless, like he can't believe what he is hearing.*) It was just
one of those days.

JOE: I just need you to come with me.

DES: You wake and before you even –
JOE: Come on we'll make a night of it.
DES: Before you even…before you…in my dream there –
JOE: Jason has it all fixed.
DES: Jason has it all fixed.
JOE: What else are you going to do.
DES: Study I could…study…I could…
JOE: Listen it's a one off thing, just a favour, think of the
 money, Des.
DES: Have you completely lost your mind? What's wrong
 with you? You stupid or something?
JOE: (*Shouting.*) I'm not stupid Des, don't call me stupid.
 (*Cut to DANNY.*)
DANNY: They're leaving,
 I think,
 open one eye slowly then another,
 only Mrs Combers left,
 I'm okay now,
 I'll be all right,
 really,
 really I said,
 I'll just go on home now and my Mam will mind me,
 my Mam will…
 my Mam –
 (*Look back.*)
 Bye now…
 Can't go home,
 can't…
 just can't.
 (*Cut to the boys on the cliff.*)
JOE: What are you going to do, you going to pass the leaving
 on a week's study yeah?
 You going to stay here in Killshoran for the rest of your
 life? It's a once off thing, it's just a favour, I hear you and
 Danny talk about going away, when you think I'm not
 listening of course, but now you could go as soon as the
 exams finish…
DES: I'm not going with you.
JOE: Why? You too afraid? Always the same always, off you

go then, back to your tractors and trailers.

DES: Why can't you just leave it? I said

I'm not going so just leave it.

JOE: Spreading slurry for the rest of your life.

DES: Shut up or I'll –

JOE: You'll what Des Foley, you'll what?

You don't understand, I have to go tonight...

he's kicking me out,

my Da.

DES: He says that all the time.

JOE: He said if I got into trouble one more time and today,

I think I might have...

Mulvey he just wouldn't shut up and I can't remember

what happened but,

that was it,

that was the one last time Des.

(*Pause. DANNY begins to make her way towards them.*)

Where am I going to go Des?

This is my only chance you know,

I wouldn't ask otherwise but I really need this Des.

Really.

Please...please.

One favour,

I'm going then anyway, and you, I hear you two talk about

going away when you think I don't hear you,

you could go tomorrow if you wanted.

DES: I'm not going anywhere.

JOE: I thought you were going to Spain with Danny.

DES: Greece.

JOE: Wherever.

DES: I'm not going.

JOE: Why?

DES: Because I don't want to, I like it here you know, you

never thought about that, but I do, and maybe I like all the

things about this place that you hate, maybe I want to be

here, to stay here.

JOE: Fine so come for me then, come 'cos you're my friend.

DES: It won't work.

JOE: Of course it will work, I told you Jason has it all

figured out
and Jason you know, he's all right,
he knows about stuff,
it'll be okay.

DANNY: (*Stepping forward.*) I'll go.

JOE: (*Jumps.*) Jesus Danny don't do that, you can't be
sneaking up on people like that.

DANNY: I'll go with you, Joe, I want to go.

DES: Danny.

DANNY: I'm not talking to you Des, Joe please.

JOE: I dunno Danny, look it mightn't be safe.

DES: It won't be safe Danny you can't.

DANNY: Don't tell me what I can't do,
can I come Joe, please.

JOE: Ah Danny.

DES: She's not going, you're not going.

DANNY: I am and I'm not coming back either,
here I've been talking to you about Greece and you just
pretending all the time.
Why…to keep me happy to…
Joe please,
I want to go…
I can look after myself, I can do whatever you need me to
do.

DES: Joe, for fuck's sake.

JOE: It's her decision Des, look why don't you come anyway,
you don't have to do anything just come with us?

Scene 2

*JOE walks past the other two and jumps to bottom level, lights
up a cigarette and addresses the audience.*

JOE: This is how it's going to go,
we take it nice and easy,
the meeting is set up for one o'clock in Fusion.
We go up to the offy, get a few flagons and take it easy, find
someplace to stash the stuff, then we go to the club, have
a few drinks, and then at half twelve, Danny goes and gets

the stuff and waits outside, I'll come out at one with the
guys, make the hand-over, back into the club, leave at two,
much richer than we were when we went in.

(*DES and DANNY join the action.*)

DES: What if something goes wrong?

JOE: What could go wrong?

Scene 3

*FX change, dark feel, music and lights shadow. DANNY and JOE
inanimate, DES stands forward to narrate.*

DES: We arrive around nine o'clock
 Joe doles out the cider,
 bottles of it,
 catches in my throat.
 We take it down by the river and slugs it back.
 Danny's throwing the stuff back.
 Go easy will you.

DANNY: I said I'm not talking to you.

JOE: We better move it.

DES: We move on and I can't fucking believe this it's like
 some sort of bad dream and the cider isn't helping.
 We find a shopping trolley overturned by the docks,
 drag it over to some hedges and stash the stuff.

JOE: Take off your jacket Danny.

DANNY: Why?

JOE: To cover it why do you think?

DANNY: You take off your jacket so.

JOE: I can't,
 it's my Da's.
 I need mine,
 I need to look like I know what I'm doing.
 (*FX change, into the club.*)

DANNY: In the club my heart is swimming
 the music is pulsing strong and techno.
 The first hour or so is a dream,
 Joe has me and Des drinking whiskey in the corner,
 I'm watching the dance floor.

JOE: The minutes are passing like decades.
 My nerves are making me nervous…

Cold rivers of sweat down the back of my father's shirt,
and the sleeves are too long.
(*Rolls them up.*)
DES: My stomach is twisting with the drink,
Everyone is swimming about,
all facing the DJ,
the whole room is thumping,
I'm drunk,
and I'm on the dance floor,
with everyone,
eyes closed.
JOE: Jason says to play it easy and cool,
Jason says it will all be sorted,
His twitching is catching…
It's beginning to make me nervous,
more nervous,
my heart is punching at my chest,
the whiskey tastes of fear.
DANNY: There's a girl in the bathroom,
so pretty,
with long blonde hair,
hair like silk or something,
my own like straw,
my dress too long,
my stomach in tatters.
JOE: It won't be long now, can't be long now.
Jason says he's in the back room, wants to meet me.
Danny…Danny.
(*No answer.*)
Danny.
DANNY: What…?
JOE: Go find Des and get the stuff…I'll meet ye outside.
DANNY: But Joe I –
JOE: Just do it for fuck sake Danny, go on, go.
DANNY: Des,
And the girl from the bathroom she has her hand on his
shoulder.
She's whispering in his ear.
She's not that pretty really,

Des,

Des!

Joe says we have to go get the stuff.

DES: Now?

DANNY: Yeah, he says the guys are in another room and we
should go get the stuff now.

DES: So you're talking to me now?

DANNY: I don't have a choice do I?

I'm not going back there on my own it's too dark.

DES: The dark can't hurt you, Danny.

DANNY: We should get the stuff, meet him outside at one.

DES: I can feel it in my bones, this is the biggest mistake I've
–

DANNY: Come on Des, it's half twelve.

(FX change, out on to the street.)

DES: Back down to the docks and there's a dodgy crowd
around,

the stuff is there,

and we're on our way back up.

Racing.

DANNY: Sweating.

DES: Panting.

Danny?

Danny, I'm sorry…

(Pause.)

Really I…I didn't know what to.

DANNY: I don't want to know.

DES: But I –

DANNY: Really, I don't care,

why would I care?

(Pause.)

(FX change, outside the club.)

DES: We're at the club door.

What time is it?

DANNY: Five to.

DES: Waiting.

What time is it?

DANNY: Five past.

DES: Waiting.

What time is it?

DANNY: Quarter past.

DES: I just know it.

Then,

we could just go back now you know,

should go,

now Danny

we should go now

no looking back,

no whispers,

just us,

it's not too late

it's not too late –

JOE: (*Very drunk.*) Boys and girls...

Where have ye been?

I've been looking all over for ye, all over.

DES: We've been here a half hour Joe.

JOE: Am, yeah well,

had some business to attend to,

you know.

DES: What business?

JOE: Look Desmond I don't have to tell you fucking
everything do I?

Look there's a slight change in plan?

DES: What do you mean?

JOE: They're not here, we have to meet them somewhere else.

DANNY: Where?

JOE: Jason's told me where.

DES: Why isn't he coming?

JOE: He's a busy man, come on, look ye can stay here if ye
want and I'll come back with the –

DES: No way.

JOE: Fine then.

DES: Fine.

(*FX change, brooding, very dark.*)

We're following Joe down side streets and alley ways and
I just know we should.

Joe.

We could just go back now you know,

should go,

now Danny.

DANNY: (*Whispering.*) He takes my hand in the dark.

DES: We should go now.

DANNY: It's all hard from the chlorine and warm and

DES: White hands, hands like pearls, no looking back.

DANNY: No whispers.

DES/DANNY: Just us.

JOE: What are you two scheming?

DES: Joe it's not too late

it's not too late to –

JOE: I'm sick of this shit from you,

look go if you're going,

see if I care.

DES: Danny?

Come on, Danny, don't be stupid,

this feels all wrong.

DANNY: I've got nothing to go back to, Des.

DES: Don't be stupid there's loads of –

JOE: Look come on if you're coming.

DES: I keep my head down and say nothing,

my heart rushing, blood roaring through my ears,

round a corner and there they are,

sitting in a van,

just waiting.

Joe

Joe –

JOE: I don't want to hear it Des,

give me the stuff,

give me the fucking stuff.

DES: You're going to go over there alone.

Are you crazy, there could be five or six of them in that
thing.

JOE: (*Grabs him and they wrestle, JOE gets on top.*)

Just give me the fucking stuff Des.

DES: And I toss the bag I see it unfold in seconds.

DANNY: I can't see what's happening, it's too dark to see
what's happening,

I've lost Des's hand in the confusion, Des…Des.

JOE: Fear in sweat rivers down the back of my father's shirt.
The bag in my hand.
Have to stay cool, stay calm, focus, concentrate,
two hundred percent...two hundred percent.
DES: Run Danny run.
He's coming toward me and I start to run back towards the
street where we came from and –
Come on Danny, come with me.
JOE: I'm almost at the van door when,
I'm a friend of Jason's and I have...
Des...
where are you going Des?
Don't run if you run...
Eight or nine or them come around form behind the van,
they come at us in a rush.
DANNY: Wait for me Des...Des wait.
Then arms like concrete around me.
Dragging me down, pulling me down.
DES: And I turn just in time to see her go down,
three of them on her,
the whites of her eyes all lit up.
DANNY: (*Side of her face against the ground as if being held down.*)
Des...Des...
Are you there I can't see you, hear you.
JOE: Fear in nerve twitches up and down the side of my face,
in my throat, around my ribs,
two hundred percent...can't be here and not be here...
DES: There are two of them on me,
there's a fist against my throat,
run Danny run,
she's on her knees...
DANNY: ...on my belly...
DES: ...on the concrete...
DANNY: They won't let me go.
DES: (*Echoes.*) They won't let me go,
do something Joe,
Joe...
JOE: Fear spreading down towards my belly.
DES: I see Joe running with the bag,

back down the way we came.

JOE: The cramp shoots through my legs like fire.

Can't move.

DES: They're on him in seconds, they swarm about him like flies.

JOE: Feel the bag as it's cut from my hands, can't breathe.

DES: Can't move.

DANNY: My head is full of sand.

There's a roaring in my ears.

DES: (*Strobe introduced.*) Danny in a rain pool on the concrete,

in spasms, gulping for air,

and they've let me go,

they're just staring,

standing staring.

Open-mouthed

hold her head up,

hold,

I see her eyes close and I

I go to move but I sink way down,

way down into the blue like lead...

And into my dream

and in my dream –

Scene 4

Cut back to the post-funeral scene at the beginning.

JOE: But it really could have been a lot worse.

And apart from Mrs Casey the singing was lovely,

I liked the one they sang at the end.

What's it called?

Moving home or –

DES: Going home.

JOE: That was it, it was lovely, I liked it

(*Stands, upset.*)

I suppose we better go now,

I'd like to see the burial you know.

Just to be there.

It hasn't really sank in yet,

I think when I see the coffin going down into the ground it might, what do you think?

DES: I don't really know, Joe.

JOE: I just think it might bring it home more.

DANNY: I'd say the water over there would be warm as toast, I just bet you.

DES: I don't think her Mam would want us there.

JOE: But it wasn't…they wouldn't have hurt her…they didn't hurt us…

DANNY: And jumping in would be like…would be like climbing in to a huge big watery bed that had an electric blanket heating it all day long.

JOE: Well…

(*More upset.*)

Well we'll watch from the road then.

DES: I dunno, I might just stay here.

DANNY: And you'd come and see me.

JOE: Suit yourself so, I'll see you later then, back at the house.

DES: Can't, have soccer training.

DANNY: No whispers, no looking back.

JOE: Soccer?…the whole world's gone mad…

(*Pause.*)

Will you not come to…just to… (*Almost in tears.*) my bus is at nine o'clock.

DES: Nine o'clock.

JOE: Won't you come for a pint or something before?

DES: I will so.

JOE: Just the two of us.

DANNY: Just us.

JOE: Bye so.

DES: Just us.

(*FX change, lights and music as for DES' opening speech.*)

I am standing at the edge of the cliff, it's dark, the sky is heavy and grey and the sea is wild.

I'm looking out over the Atlantic and she's like tinfoil, with lace at her ankles in waves on the shore…

She's a cradle,

she's a mercury blue duvet and as I step out onto the air,

she's a soft wall flying up to meet me and I'm through,
and I'm going way down into the blue like lead,
and I lie face down in the deep black sand and
open my mouth and breath in the blueness,
touch the stars that are diamond cool and smooth in my
hands.
And I see her come towards me.
She's so beautiful and she talks to me softly.
And then moves to go.
Can't you stay?
Stay a while longer,
I'll be a good boy.
And she holds out her white hands, soft hands, hands like
pearls.
And we walk together across the soft black sand,
stepping carefully about the stars,
and I know,
I know I won't ever have to let go.
(*FX sound of DANNY laughing. The ocean. Blackout.*)

The End.